SPASM
Virtual Reality, Android Music and Electric Flesh

CultureTexts

Arthur and Marilouise Kroker General Editors

CultureTexts is a series of creative explorations of the theory, politics and culture of postmodern society. Thematically focused around key theoretical debates in areas ranging from feminism and technology to social and political thought, CultureTexts books represent the forward breaking-edge of contemporary theory and practice.

Titles

SPASM

Virtual Reality, Android Music and Electric Flesh

Arthur Kroker

St. Martin's Press
New York

All rights reserved. For information, write:
Scholarly and Reference Division,
St. Martin's Press, Inc., 175 Fifth Avenue,
New York, NY 10010

First published in the United States of America in 1993

Printed in Canada

ISBN 0-312-09681-X (pbk.)

Library of Congress Cataloging-in-Publication Data

Kroker, Arthur 1945-
 SPASM : virtual reality, android music, and electric flesh / by
Arthur Kroker.
 p. cm. — (CultureTexts)
 ISBN 0-312-09681-X
 1. United States—Civilization—1970- 2. Arts, American.
3. Arts, Modern—20th century—United States. 4. Postmodernism-
-United States. 5. Virtual Reality—United States. I. Title.
II. Series.
E169.12.K77 1993
973.92—dc20
 93-20262
 CIP

For Marilouise, with love

Acknowledgements

I wish to thank Marilouise Kroker for her intellectual and artistic contributions to this book.

I am grateful to Bruce Sterling, Steve Gibson and Michael Boyce for encouragement and intellectual support as well as to David Cook and Michael Weinstein for reading the manuscript in preparation.

Research for this book was facilitated by a grant from the *Social Sciences and Humanities Research Council of Canada.*

CONTENTS

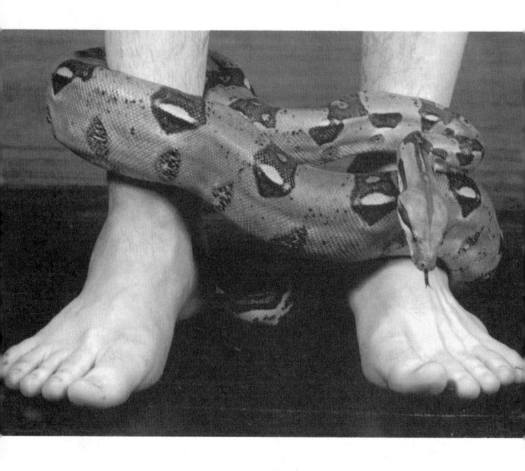

Pierre (Three Part Body Series)
Photo: Linda Dawn Hammond

PREMONITION OF SPASM
or WHY I READ ARTHUR KROKER

Bruce Sterling

I'm not a cultural theorist, political scientist or feminist body theorist. I think it would be wise to 'fess up right now and admit that I am a science fiction writer. "Normally" (whatever that means in the 90s) as an autochthonic inhabitant of a transgressive and lumpily mutant lowbrow genre, I would never have read Arthur Kroker. Frankly, I only stumbled across Arthur Kroker because, in antlike fashion, I was following the scent-trail of people dressed in black.

I myself customarily dress in black. So does Arthur, apparently. I've noticed over the years that a certain fraction of the entire populace of the Group of 7 dresses in black. I'm still not sure what it is that these people have in common. Very little, probably. But as the forces of reaction have intensified, this minority group has been force to coagulate in unseemly, recombinant fashion. People once light-years apart are now cheek-by-jowl. The gaudy wire-racks of my own native sci-fi are

now starting to sprout certain eldritch pomo excrescenes, sort of like that scene in the Cronenberg *Fly* where an insect leg burr (anagram for Bruce Sterling) pokes out of Jeff Goldblum's erotically sweat-soaked back.

Or is it just the opposite? Political theory reduced to the incoherent, rambling status of science fiction, political theory which has detached itself from any pragmatic and quotidian concern and now looms across the landscape as a vast shapeless premonitory cloud... Theory as Chernobyl. Arthur Kroker as an enantiodromic as-tronaut. It's amazing the mileage that Arthur Kroker wrings out of that little two-letter adverb "as." If you had the text of SPASM as an electronic ascii file (which would be kind of a cool digital move, actually), you could do a word-search in here for those ninja-like uses of "as" in the Kroker rhetoric and you could learn something useful. That, and that way-judo move where he says *"or is it just the opposite."*

Actually that's one of the main charms of this particular rugby scrimmage, Baudrillard to Deleuze to Guattari to Barthes to Lyotard; they have all the appealing looniness of the extreme left without there being any real-world probability that they can establish camps for the incorrrect. Kroker, being bilingually rubberboned, has a markedly tenacious grip on these Nanterre U. types, but he's so far beyond *left* that even to map his position in the political spectrum would require some kind of non-Euclidean hyperspatial Klein bottle. It's like in *The Hysterical Male*, the "feminist body theory" book he and Marilouise edited, it's the kind of "feminism" where there's nothing you can do to "advance the cause of women" short of jumping right out of your skin and spontaneously combusting. Man, that stuff is fun to read. I get a glow off it that lasts all day.

Actually, I see stuff around me every day that's Krokerian. I can't watch CNN or C-SPAN for more than half-an-hour

without a Kroker take intruding on my cable-assisted stream-of-consciousness. The Krokerian bodiless eye has virally infected my weltanschauung with apparently permanent effect. Take, say, Al Gore's *Earth in the Balance.* Y'know, as books by politicians go, that's a pretty good book; it's very modernist and sensible, and establishes a coherent line of argument and tries to hew to it and to convince the populace to go along with gentle sweet reason and all that; but there are any number of Krokerian episodes of male hysteria in it. Like when good old Southern Baptist family-values Al is visiting the hideous dustpit that was once the Aral Sea. There's like a moment of Krokerian truth there when even suited blow-dried Al realizes that it's the 1990s now and if you're not *absolutely wigging out* then you're basically clueless. It's that Krokerian eruption of ecstacy and dread. *He's not making it up*, goddam it! *It's actually out there.*

And then you realize that there are people around like Reagan, who really thinks that trees cause pollution, and you simply *go nonlinear;* you realize that the gigantic cultural engine that is Virtual America has been in the hands of dimwitted admen for twelve years, and the damage, like the damage in the formerly Soviet Union, cannot even be *assessed.* It seems the only hope is to somehow render the whole episode into a kind of historical black-hole, a self-swallowing TV image that vanishes into a point of light before the channel switches and all that was white is black.

The events that happened to the East Bloc in 1989 — the most important political and social events of my lifetime to date — made *no sense.* I don't think anybody could have *predicted this.* However, having read Kroker, I find myself mentally prepared to *swallow it.* I find myself prepared to believe that some virally potent thing in the postmodern imperative simply melted a sixth of the planet. And when Kroker says something like "We are the first citizens of a society that has been eaten by technol-

ogy, a culture that has actually vanished into the dark vortex of the electronic frontier," I find myself prepared to *agree*. I agree, and I soberly nod my head, and I kind of roll the beauty of that phrase over my tongue, and then I spit it into the bucket of sawdust I keep beside my personal gigabyte hard-disk. And then I log onto the WELL and read my e-mail.

It's not that my mind isn't blown, because it is, regularly. It's not that my subjectivity doesn't fragment. Yes, my subjectivity is just as chopped-and-channeled as Steve Gibson's technopop sampler music. It's just that, having read Kroker, I can actually enjoy this. I take that same terrible wormwood-scented absinthe-sipping fin-de-millennaire pleasure in the awful truth that Kroker himself so clearly takes. You kinda have to see Arthur do his thing in public to realize the true depth of his life-giving effervescence. He says these dreadful, utterly maddening things in that dry, scalpel-sharp tone of his, and people absolutely laugh their asses off. They laugh until they get a kind of terrible nebulous pain behind the floating rib, and when it's all over, they feel as if they've had Filipino psychic surgery. They feel as if some kind of terrible malodorous thing has been miraculously identified, grubbed out, removed from within them, and displayed in a formalin jar. And they go out blessed by the double-sign of overloading and excess.

May we all be so blessed.

Bruce Sterling is the author of *Islands in the Net; The Hacker Crackdown: Law and Disorder on the Electronic Frontier;* co-author with William Gibson of *The Difference Engine;* and editor of *Mirrorshades: The Cyberpunk Anthology.*

1

SPASM

Spasm is the 1990s

A decade that stretches before us like a shimmering uncertainty field in quantum physics: its politics intensely violent, yet strangely tranquil; its culture conspiracy-driven, yet perfectly transparent; its media seductive, yet always nauseous; its population oscillating between utter fascination and deep boredom; its overall mood retro-fascist, yet smarmingly sentimental.

Spasm is a book about virtual reality, android music, and electric flesh. Refusing to stand outside virtual reality (which is impossible anyway), this is a virtual book, half text/half music. A floating theory that puts in writing virtual reality's moment of flux as that point where technology acquires organicity, where digital reality actually comes alive, begins to speak, dream, conspire, and seduce. Here, virtual reality finally speaks for itself through a series of stories about a floating world of digital reality: floating tongues, noses, sex, skin, ears, and smells.

Spasm, therefore, as a theory of virtual reality: its mood (vague), its dark, prophetic outriders (three android processors: a sampler musician, a recombinant photographer, and a suicide machine performer), its ideology (the fusion of biology and mathematics as the command language of recombinant culture), and its cultural horizon ("scenes from recombinant culture"). Implicit to *Spasm* is its attempt to articulate a critical cultural strategy for travels in VR: a strategy of double irony, involving ironic immersion (in the real world of data) and critical distancing (from the power blast of the information economy). Consequently, *Spasm* is a virtual theory of those organs without bodies that come to dominate the electronic landscape of digital culture.

Spasm: The Vague Generation

There are no longer any necessary connections between culture and politics; it is now possible to be culturally hip, yet politically reactionary. Lifestyle has fled its basis in the domain of personal ethics, becoming an empty floating sign-object—a cynical commodity—in the mediascape. Consequently, the persistent question asked by the newly subscribed members of what Michael Boyce has named the vague generation: "How did you get your lifestyle?" The vague generation can be so sharply analytical in their diagnosis of the growing epidemic of conspiracy theories because their mood runs to the charmed atmosphere of *floating reality*: floating conspiracies, floating bodies, floating moods, floating conversations, floating ethics. But then, maybe we are all members now of the "vague generation" living under the fatal sign of *double irony*: floating between a fused participation in digital reality which is equivocal because our bodies are being dumped in the electronic trashbin, and our

attempts at withdrawal which are always doomed because technique is us. Virtual reality is about *organs without bodies*.

Or as Clinton, the perfect hologram of the manic-buoyancy phase of the American mind, said recently:

> This is an expressive land that produced CNN and MTV. We were all born for the information age. This is a jazzy nation, thank goodness for my sake, that created be-bop and hip-hop and all those other things We are wired for real time.
> *The New York Times*

But then, all conspiracy theories are true. But for those who refuse to kneel to the rising sun of liberal fascism, who refuse to assent unequivocally to the vision of technology as freedom, not degeneration, another hypothesis might be suggested. The electronic cage is that point where technology comes alive, acquires organicity, and takes possession of us. Not a seductive experience, but an indifferent one flipping between the poles of narcissism and cruelty. Not a cold world, but one that is heated up and fatally energized by the old male dream of escaping the vicissitudes of the body for virtual experience. And "wired for real time?" That's virtual reality, the ideology of which could be triumphantly described by Marvin Minsky of MIT's Multi-Media Research Lab as the production of cyber-bodies with the soft matter of the brains scooped out, and skulls hard-wired to an indefinite flow of telemetry.

Heidegger was wrong. Technology is not something restless, dynamic and ever expanding, but just the opposite. The will to technology equals the will to virtuality. And the will to virtuality is about the *recline of western civilization*: a great shutting-down of experience, with a veneer of technological dynamism over an inner reality of inertia, exhaustion, and disappearances, and where things are only experienced in the

SEX WITHOUT SECRETIONS

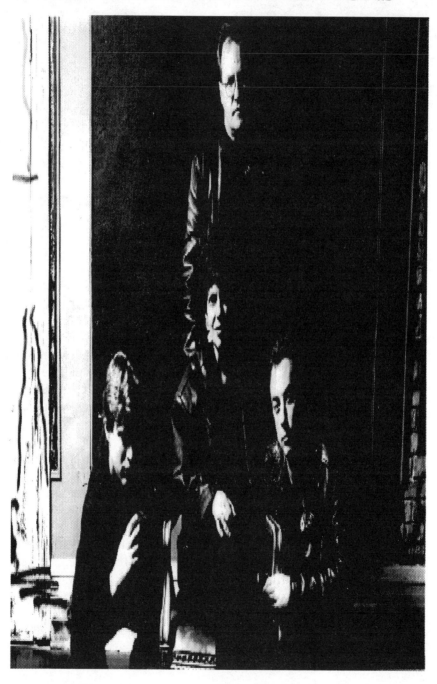

"real time" of recycled second, third, and fourth-order simulations. And everyone has got into the act. Even that Berlin fireman who was caught recently videotaping, instead of fighting, a 4-alarm blaze for Germany's *Reality TV*.

Spasm: Riders of the Crash Zone

Spasm is, in part, the story of the dark outriders of virtual reality. Three individuals—Steve Gibson, Linda Dawn Hammond, and David Therrien—who, like Old Testament prophets wandering in the desert, are the new rugged individualists travelling through the sprawl of the digital frontier of the Year 2000. A music hacker, who rides the crash zone of sampler technology to bring back the sounds of the body recombinant. A body hacker, who records in her photography the coming shapeshifters of digital reality. And a high-voltage electro hacker, who has reinvented his body as a suicide machine, half-flesh/ half-metal, in the desert of Arizona.

I have a hyper-rock band called *Sex Without Secretions*. Not an art school sound, but a real death-metal sampler music band. Unfortunately, one night our lead guitarist got himself shot in a bar in Buffalo after someone in the audience yelled out: "This is all intellectual bullshit." That's how I met Steve Gibson, a music hacker who came highly recommended out of the darkest outlaw regions of cyber-space: an electronic sampler musician who had actually broken the secret codes of digital reality, made the S-1000 Akai sampler break out into strange hybrid songs, and transformed himself in the process into a mutating android processor.

SEX WITHOUT

SECRETIONS

It was a typical cold winter night at *Foufounes Electrique*s in Montreal, a kind of *BladeRunner* bar where primitivism meets high tech and where bodies go to download into music. *Gwar* was performing, you know the band that likes to advertise itself as "twelve ex-art students from Virginia"—whatever that means—and who specialize in sacrificial blood rites: hosing down their audience with simu-blood, chopping off papier-mâché penises, and goat butting. In other words, an all-American band. In the midst of the pandemonium, I noticed a photographer, Linda Dawn Hammond, right at stage level calmly taking pictures. She came dressed for the occasion with a see-through plastic raincoat over black leather, blood red hair, and Camden Town heavy-stud leather boots. As I found out later, while her *Gwar* photographs were interesting, this was just a job on the way to her real work: a spectacular, and perfectly unknown, photograhy project—*3-Part Body Series*—that captured, in a haunting, deeply evocative way, the fetishistic rituals of crash bodies occupying the outlaw margins of virtual reality. Like a Dianne Arbus of cyberspace, but only better, Hammond's photography was the truth-sayer of body hackers who travel as shapeshifters across the digital galaxy.

For years, I have been hearing rumours about something extraordinary going on in Phoenix, Arizona. *The Icehouse* and David Therrien. Unlike the heavy macho crash machines of California, that appear lost in the brilliant glare of the virtual reality simulacra,there was something very different happening in Phoenix. And all the rumours kept circling back to David Therrien, a high-voltage electro hacker, who had actually created a fantastic android oasis in the desert, a *Gallery of Machines*: electric inquisition machines, suicide machines, INDEX ma-

chines, comfort machines, 90 Degree Machines, and Fetal Cages. *The Icehouse*, then, as a culture lab for seducing the inert world of cold metal, making the algorithmic codes of sampler culture break out into techno-screams, forcing it to announce that technology is no longer a specular commodity nor even an icon, but that final evolutionary phase of *living species existence*. David Therrien is the alchemist of digital reality, the first and best of all the American desert prophets. And I knew that I had to take a nomadic migration to Phoenix, to *The Icehouse*, to see for myself the hybrid products of his alchemical computer lab.

In part, *Spasm* is about these three deeply romantic figures, working in isolation and certainly outside the canons of official culture. Their works are perfect screens for our violent descent into the speed space of virtual reality. To the extent that virtual reality is a global aesthetic, occupying no specific territory but invading all of space and time, these artists are the pioneers of the swiftly emerging digital frontier, dark outriders of hacker culture who recover in advance the android sounds, recombinant photographs and burning electronic flesh of digital technology.

Spasm: The Conspiracy

Consider *JFK*, the movie. It can be so popular today because it is itself a covert part of the American conspiracy.

Not really a conspiracy of the Left or Right, but a predictable part of the American conspiracy, of America itself as a covert operation that always works to imprint its official faith—the American hologram—on the world. And that faith, whether

liberal or conservative, is the founding myth that America, for all of its blemishes remains the greatest goddam country in the whole wide world.

Ideologically, *JFK* is, of course, the liberal side of the American sacrificial myth. In a modernist pique of nostalgia, it wants to stabilize the uncertainty field of America around a new animating vision. The Sun King has been slain, his murderers sit on the throne, and it is the responsibility of we, his children, to right the historical injustice of "the greatest crime ever committed." A reanimating myth that can be so infected by a liberal zeal for the resuscitation of truth-value because it is already an after-image of the disappearance of America into a more advanced stage of nihilism: a form of cynical consciousness where what seduces is what Nietzsche prophecied—the joining together of nausea and pity to produce monsters. A hybrid form of monstrous consciousness of goodness suppressed, of cynical sentimentality, that can claim that the years since the assassination have been those of violence and pestilence. This is clearly mistaken. America's animating spirit has always been that of regeneration through violence and that of disappearances: the disappearance of the Other as objectified scapegoat, of historical memory, and finally the vanishing of America into its own photographic negative. What Californians like to call Virtual America.

Virtual America? That's *JFK* playing out the murder of the President as a spectacle, complete with its own magic kingdom of the "magic bullet." Just perfect for a virtual America that reproduces itself under the sign of the twin spaces of illusion. The *liberal illusion:* that's the narrative of Camelot and the Fisher-King driven by the will to truth. And the *conservative illusion:* that's the more biblical faith in America as a covenant with its own will to faith. This bimodern America of sliding signifiers propels itself into the future as a great flashing sequencer by instantly reversing

fields, sign-switching between the poles of truth and faith, liberalism and conservatism, systematicity and chaos. A sacrifical ideology, therefore, that constantly reenergizes itself by instantly repolarizing the schizoid poles of the American mind.

Anyway, maybe *JFK* never was murdered, because *JFK*, as something real, never really existed. Maybe *JFK* was then, as he is now, an empty scene for cancelling out all the big modernist referents: a violent space of illusion in which the poles of the Kennedy referent could oscillate wildly? Who was *JFK*? An "Excalibur sinking beneath the waves" or a real '50s-style playboy? Or both? The fatal sign of *JFK* is so endlessly seductive because it is simultaneously a site of hyper-nostalgia for an America that never really existed and a scene of hyper-excess for a sexuality that could never be satisfied? And who was Oswald? An assassin of the American Sun-King? Or a real American patriot who secretly and desperately worked to save Kennedy's life? Oswald, then, as a schizoid sign, just like the sliding sexual signifiers of David Ferrie and Clayton Shaw.

There were many murders on Daley Plaza that day in Dallas. Certainly the shooting of the President (he was fired as a policy decision made by the war machine), but also the public assassination of the legitimacy of the liberal myth and the killing of the silent mass of the American public. As in Machiavelli's *The Prince* before it, this was a deliberately public murder intended to demonstrate to the silent majority its powerlessness to control the American narrative.

But now that Communism has gone into eclipse and the Conservative cycle has lost its missionary zeal, maybe it is necessary to reactivate the liberal vision of America as a way of reenchanting the American dream. *JFK*, therefore, with its zeal for the grail of the lost referent as the Grand Canyon of contemporary American politics. The assassination of *JFK* as precisely

that moment in which the USA flipped from modernism, with its stabilized poles, to an American postmodernism of sliding signifiers. Welcome, then, to *Spasm* USA.

Spasm: The Glamour Addict

I once did some work for the President of a California computer company that specialized in consumer electronics for virtual reality. Not satisfied with the old merchant world of computer graphics, he was a glamour addict who desperately wanted to go Hollywood. With Madonna-like stardom on his mind, he wanted to inscribe the idea of a rock band onto a new kind of computer company, called *Crash*, that would consist of himself (a businessman who yearned to be a rock star like a cyber-Medici), myself (a theorist of crash products for the body telematic), and an acupuncturist. Thinking of myself as (Canadian) software to California hardware, I immediately enlisted for virtual reality bootcamp.

Classical hubris was the only mythological problem. Having somehow got wind of this new business plot, and probably in a paroxysm of speed-consciousness after having read Ballard's novels, the main-frame computers in his own company decided to take the President at his word and go crash immediately. Which is exactly what they did. With no warning, the computer electronics company went into a violent business *spasm* and crashed: its stocks went into a fatal free fall, financial newsletters were filled with resentful articles ridiculing his glamour-addiction. The President himself had to take a quick flight to Tokyo for a public spanking by his investors, and even the acupuncturist went back to needling people. This was one computer entrepreneur who tempted digital fate with the word crash as

the name of a new company, and who, in a replay of classical hubris, overreached himself and got what he deserved. The electronic gods of digital reality, the computers, easily outsmarted him and crashed his company, taking his fortune with it. The last I heard of him, he had vanished into the desert, probably heading for Yukka Valley, California.

Not just the computer entrepreneur, but everyone now comes under the mythological spell of digital reality. We are the first citizens of a society that has been eaten by technology, a culture that has actually vanished into the dark vortex of the electronic frontier. A recent advertisement from SONY got it just right when it suggested (triumphantly) that in the Year 2000 *Walkmans* would be strutting around with little people dangling from their ears. With this big difference. At the millennium, *Walkmans* probably won't exist (and SONY neither) because we will be floating around in the world of *Crash Walkmans*, that new electronic frontier for digital ears where, when you insert a coded micro-chip for the mood of the day (*Guns n'Roses* news, *Studs* weather, *Magritte* music), an instant resequencing of the universe of digital sound results. Here, the old world of analog sound disappears, and is replaced by a digital sound spectrum that can be sampled and resampled by a crash body moving at spectral speed—a crash body that arcs across digital reality like a dark outrider of the age of android subjectivity.

Not only will sound be digitally reinvented, but all the senses in the universal media archive: virtual eyes, cyberfingers, liquid crystal skin, feel patches for the quick repolarization of the body's magnetic field. Ours will no longer be a prepackaged digital environment; everybody will be a media hacker, recoding the electronic frontier at will. The crash body, therefore, as a fast digital cut disturbing, intercepting and mutating the vast galatic space of data.

* * *

Spasm: The Leaking Biosphere

You can find the famous *Biosphere 2* just north of Tuscon, Arizona in a beautiful desert valley that used to be a vacation rest stop for weary Motorola executives.A perfect architectural model of the transcendental principles of theosophy, funded by adamantly Texas "free enterprise" money, and energized by the fusion of technocracy into a religious cult, it's a perfect, monstrous hybrid of Disney World and NASA.

Buy your entrance ticket and the Star Trek attendant beams down to you—"Welcome Aboard." Go on the regular tour and you are immediately processed through a cinematic experience in which the *Biosphere* lifts off from earth, becoming a model for sustained humanoid life in outer space. See the *Biosphere* on the moon. See the *Biosphere* on Mars. See the *Biosphere* on Jupiter. See the *Biosphere* in hell. Walk the walk and tour the tour and the beaming guide invites you to ask questions directly to the *Biospherians* . So you write "What would Nietzsche think of the Biosphere? Is this what he meant by suicidal nihilism?" But, of course, your question isn't one of the few chosen to be put to the *Biospherians*, busy as they are in the "first enclosure," the first extraterrestrial pioneers of a one hundred year experiment. You sit with the crowd in the communication module (right next to Mission Control), and the guide asks some of our questions to screened images of the *Biospherians* . And it's perfect. It is supposed to be a live multi-media interaction between the antiseptically clean world of the *Biospherians* and the dirty outsiders (that's us), but it's really a sampler talk show. The questions selected are general sampler queries ("What exercise do you get?'" "Why have you sacrificed so much to be a *Biospherian*?" "How can we become *Biospherians* ?") After each

16

question, a prepackaged image of an earnestly happy member of the *Bisopherian* family (the doctor, the horticulturalist, the engineer, the sea-life ecologist, the computer whiz) is downlinked to us: witnesses of the first enclosure. But then, just like in a great sci-fi horror film the video images go mutant, at first "live" images zoom by on fast forward and then, in a perfect digital parody, the same image-frames flip onto an endless loop. We should be in consternation at the media trickery, but everyone suddenly relaxes. This is TV and we're all experts in the trompe l'oeil of the universal media archive.

Biosphere 2 is just like P.T. Barnum strained through the technological imperative: a perfect fusion of the travelling carnival show and high technology. With this difference. The *Biosphere* is a perfect crystallization of technocracy's loathing of nature and human nature. Of nature? It was proudly reported to us that the first words of one of the *Biospherians* who had just exited into the clean desert air from a long stay in the artificial environment of the prototype *Biosphere* were: "Yuk! The air stinks out here." And of human nature? That's the escape theme that pervades the promotional language of the *Biospherians* : escaping from earth, escaping from the body, escaping from America. A whole technological experiment that has, as its overriding goal, achieving escape velocity from the gravitational pressure of nature and human nature.

And, of course, the predictable result. Two rebellions. First, nature rebels: the vegetative kingdom of the *Biosphere* explodes under the pressure of the hot Arizona sun, emitting CO_2 with such intensity that the air quality of the *Biosphere* is quickly poisoned; raging hordes of mites escape the vegetative kingdom, making the Biosphere, living quarters and all, their new artificially sustained home; monkeys migrate from the jungles, peering down from the steel rafters, while the *Biospherians* try to eat, and raid the dwindling food supplies; and even the slick-assed

machines get into the act, cutting fingers off the *Biospherians.* The much-vaunted "first enclosure" quickly turns into its reverse: a story of the leaking biosphere. Leaking oxygen (10% of the air supply has been replenished); leaking power (an external power generator has been installed to run the internal machinery); and leaking species (all the environmental modules have gone into speed *spasm*, with all the species refusing their traditional places in the modernist hierarchy of evolutionary values).

And finally, human nature rebels. At the very end of the tour, we turned the corner of the final building, still waiting for a glimpse in the flesh of the *Biospherians* inside. Suddenly, a member of our tour group yelled out: "There they are." Everyone rushed to the windows for a glimpse of the fabled earth-escapees. And there they were: the cream of the technocratic elite, terribly emaciated (the *Biosphere* had just experienced two crop failures in quick succession), on their hands and knees in the cyber-soil desperately trying to get something, anything, to grow. On seeing the earth-bound plight of the starving *Biospherians*, an instant mood shift swept across my tour group. To that point, everyone had been in awe of the technological superiority of *Biospherian* culture, but that immediately flipped into a collective feeling of pity, and maybe even contempt. Without a word spoken, everyone in my tour group turned from the window on the Garden of Eden in ruins, breathed in the desert air, looked at the spectacular nature scene around us, thought of a cold beer at the old Motorola bar up the road, and happily left the *Biospherians* to their illusions.

* * *

LATEX

SEX

Spasm: The Recombinant Sex

Elvis, Madonna and Michael as the New Entertainment Trinity

I recently received a letter from Ken Hollings, a British friend, who had this to say about the London club scene:

> Rave culture in the U.K. has gone so hardcore now that it almost is like a cartoon--there's so much speed around that music sounds like it's being played at the wrong RPM setting--BPMs of over 240! I think that the London raver is going to replace the diehard punks with their leather and multicoloured mohicans as a tourist attraction. However, the bondage/europerve scene is really expanding--SM parties are the new forum for safe sex in the fallout zone--latex and rubber as metaphor for the new *cordon sanitaire*. Desire in a time of declared emergency.

In the age of sex without secretions, latex sex is everywhere. Blocked from its (natural) ground in the free exchange of bodily fluids, sex flows from the wetware of the now probibited arena of sexual secretions to the dryware of sado-masochism lite. It leaves behind the body with its dangerous liquid flows and waste fluids, and jump cuts for the more alluring shores of *cold sex* (Madonna), *pure sex* (Michael Jackson) and *dead sex* (Elvis). Madonna, Michael and Elvis, then, as the new entertainment trinity (ET) of the age of global aesthetics.

Cold sex? Think of Madonna Mutant who in her most recent incarnation as Marlene Dietriech Vamp (just before she does a final sexual reversal and begins to spout 'No Sex before marriage' in time for the end of the millennium), appropriates the media territory of SM. Not sado-masochism like in the good old

PURE

SEX

days of Berlin sex clubs where the blending of liturgically inscribed pain and sweet pleasure was done on a tableau of blood, but now SM boutiqued. A photographic journey of erotica for a culture of the distended eye that privileges the disappearance of sex into an optics of sexual penology, of SM under the lash of the camera's eye. All of this wrapped in a simu-prophylactic as if to doubly reassure us that leather and plastic today are just another way of mylaring the waste flows of bodily secretions. And so: Madonna Mutant as cold erotica for a cool sex that does everything to escape the wetware of the body. White heat for a cold time, oscillating between melancholia and euphoria.

Pure sex? That's Michael Jackson in his big comeback show with Oprah after fourteen years of reclusion in the fairy tale spectacle of Neverland Ranch, California, decided to resequence his televisual replicant in the saintly image of the Lamb of God. And so, a quick series of denials all delivered in the very best injured tones of the sacrificial lamb: No, he doesn't sleep in an oxygen chamber; No, he didn't kill Bubbles; No, he doesn't have incestuous thoughts about LaToya; No, he wasn't deliberately bleaching his skin hyper-white; No, he didn't propose marriage to Liz Taylor. And finally, to the question of cosmetic retooling, the Michael Jackson replicant is a product of no more than two surgical redesigns (his collapsing nose most of all). If Michael could demythify his private self with such energy, it's because he has already passed beyond the earthly sphere, ascending to the level of an entertainment god. Not the "King of Rock, Pop and Soul," as Liz gushed at the music awards, but the first of all the android gods produced by the mediascape. A deeply religious figure living in a perfectly transcendent state (Michael tells Oprah that music is a link between the human and the divine and that he "is honoured to be chosen to be an instrument of nature" between, we suppose, earth and the heavens above), Michael is a Lamb of God for the electronic age: a sacrificial figure

of abuse who ritualistically invests in his tabloid body all the resentful fascination for our own inadequacies, and who links himself directly to a global chain of children held to be in a perpetual state of innocence.

The proof of this? Well, as Michael says to Oprah, if you really want to know who I am, read my book, *Moonwalk*. Exactly right. If you want to know the sacramental rites of the Lamb of God, you must read the Gospel of the electronic media way. *Moonwalk* is a deeply mystical text, an American New Testament, hovering like Michael's wonderful dancing legs somewhere between the edge of the music and the sounds of the transcendence trapped within, making the case for a silent complicity between childhood innocence injured by a cynical time and the lonely star of the Jackson Replicant. It might be, of course, that the pure sex of Michael Jackson is just a clever promotional twist, a way of reprogramming his electronic body for the chloroform culture of the nineties, but it might also be that like Jesus Christ before him, Michael Jackson actually is what he suspects himself to be, a "chosen instrument," a Lamb of God who thus makes of his body a site of a double cancellation: pure sacrifice and pure energy. If this is the case then the song-line of Michael Jackson from *Thriller* to *Dangerous* is in the nature of a universal religious event, a point finally beyond entertainment aesthetics and in the sanctified domain of the sacrificial lamb. This would explain in part the awesome nature of the "Jackson phe-nomenon": beyond music and the fibrillations of dance, Michael makes worshippers of everyone, participants in the unfolding of the greatest religious spectacle of all times, the Jackson World Tour. The last Lamb of God said, just after they crucified him and he was bodily resurrected on his way to his heavenly home, that he would return to Stateside someday. Who would ever suspect the Jesus of the Gospels living midst the ferris wheels, roller coasters and animal rides in Neverland, dealing with Sony, capturing our fascination with his perfect rough pitch of rock and recombinant dance, and all the while beginning again a children's crusade

that hasn't been seen since the great Medieval pilgrimages. An electronic Jesus with a message of pure sex for the new lost generation.

And **Dead Sex**? That's dead Elvis who, in a brilliant reversal in advance of Michael's comeback on a talk show, appeared on the TV screen in outlaw black, looked the camera in the eye and said: "If you're looking for trouble you've come to the right place." Just like James Dean and Marilyn before him, no one knows better than Elvis that in the dark, gaseous galaxy of the electronic body, dead sex is the very best sex of all.

2

SCENES FROM THE
RECOMBINANT BODY

The Floating Tongue

What is the fate of the tongue in virtual reality? No longer the old sentient tongue trapped in the mouth's cavity, but now an improved digital tongue. A nomadic tongue that suddenly exits the dark cavity of oral secretions, to finally make its appearance in the daylight. Like *Spasm*, the new computer programme for NEXT, where the digital tongue is exteriorized from its evolutionary location in the body's biology, actually severed from the mouth. Here, the tongue might begin by curling back in the mouth with all the accompanying nasal sounds, but then it migrates out of the mouth, travelling down the chest, out of the toes, and even taking libidinal root in the talking penis. Not a surrealistic penis where objects lose their originary sign-referent, and float in an endless sign-slide, but a tongue referent that has actually lost its sound object. *Spasm* is, then, surrealism that is inscribed in the flesh.

With this difference. The digital tongue has finally come alive, acquiring sounds from its different bodily referents. The

23

tongue plops onto the chest with a gargled scream; it twins the hyperreal penis to the mutant sounds of sex without secretions; it becomes a toe sound, a knee sound, an anal sound. No longer a tongue mediating breath, lips and jaw movement, but a digital tongue in a universe of floating lips, chattering eyes, screaming hairs, gossipy genitals, whining feet.

The digital tongue samples the body. Working according to the logic of spatial association, it changes sound according to its location on the body's surfaces. Here, the text of the body is licked and consumed by the nomadic tongue: sometimes an arm, a vein, an intestine, a hip. No longer localized sound, but the speech rhythms of violent disassociation; not contextualized noise, but a floating tongue that can be endlessly reconfigured according to its geographical location in the simulacrum of the body. The digital tongue, then, for nomadic sound in the age of the floating body. Or maybe it is something very different. Perhaps *Spasm* does not refer at all to the digital tongue, but to the recombinant tongue. This algorithmic tongue comes alive as a gene-splicer—half-gene/half-code: displaying that point where the reconfigured tongue fuses with the cold flesh of the recombinant body, and begins to speak. Perhaps *Spasm* has a broader anthropological importance: an evolutionary break-through in the guise of a computer programme that begins to materialize the sounds of the digital body. What we hear in *Spasm*, therefore, are the first tentative sounds of ourselves as androids. All of this results less in a vision of the future than an already nostalgic vision of a telematic history that has already been experienced.

Spasm is nostalgia for distortion.

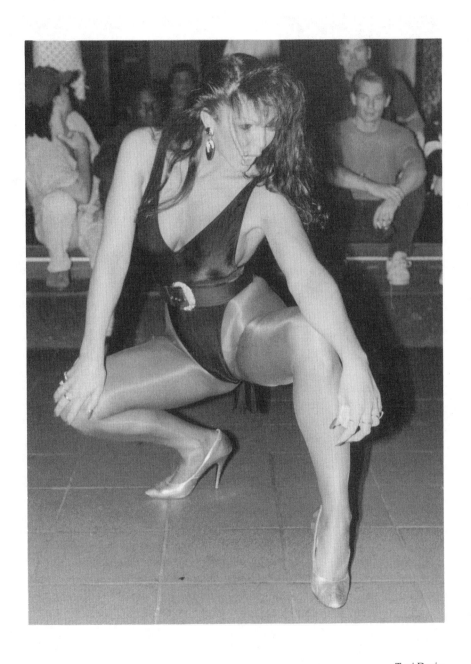

Toni Denise
Photo: Critical Art Ensemble

Toni Denise

I have a recombinant brother, Toni Denise, working the drag queen bars of Tallahassee, Florida. She has taken her memory and put it aside for a moment.

She is not just a guy who warp jumped into a woman's body by surgical cuts, but the first of all the virtual bodies, that point where Disney World becomes flesh: a double movement involving an endless remaking of sexual identity and an abandonment of the (gendered) past.

Toni Denise. The perfect transexual woman. More perfect than a woman ought to be, or can be: slim hips, large breasts, shoulder length raven hair with legs as long as Barbie's.

Toni Denise. Too perfect to be a real woman? The picture perfect woman? The woman all women think a woman should be? Toni Denise is a man-made woman. A woman made from a man. A man with slim hips, long legs, and raven hair. A man who could say no to cellulite, and yes to silicon breasts.

Toni Denise? A virtual woman or virtually a woman? She can turn gender signs inside out, and play the game of the doubled sex.

Once she became a woman on the outside, she could finally take on the seduction of the male psyche and become the male mind colonizing the female body. Or as Toni Denise likes to say "If I had a clit, I'd have a hard on."

Toni Denise was written with Marilouise Kroker

The Transistorized Face:
Give Me Your Code

For many years, doctors have been injecting silicone into women's faces. Now a New York City doctor has outdone the procedure by taking silicone from low grade transistor fluids and injecting it directly into the skin of women, disappearing facial wrinkles. This is the new digitalized, transistorized face that rewires memory: no more wrinkles, no more tears, no more history.

But the face does have a history, and a remembrance of that history. The transistorized face in New York rebels. It rejects the silicone, that tries desperately to justify its existence by sliding, seeping, weeping such that the transistorized face becomes a virtual face that floats beyond time, beyond wrinkles: it is also a face that operates under the sign of a fatal destiny. It will always oscillate between digital ecstasy and earthly decay. The scene of a greater mythological drama, the transistorized face remains condemned to an endless repetition of Nietzsche's prophecy of eternal recurrence: a physics of the weightlessness and pure energy of wrinkle-free seduction versus the earthly drag of transistor fluid as it seeps under the fatal pull of gravity to the lower regions.

The Transistorized Face was written with Marilouise Kroker

Nose Spasms

Maybe biological evolution got it all wrong. Perhaps the traditional separation of vision and smell was a big mistake, a modernist illusion of the dualistic universe (and a radically dualistic body) that was territorially inscribed on the face. Maybe the second generation body, the final stage of the now superceded phase of natural evolution, terminated in an evolutionary dead-end. So then, the virtual body, and the virtual nose with it, as the first of the great olfactory rebellions against the radical severance of sight from smell. After all, olfactory chips that can be secreted onto the eyeball like invisible smell lenses have a great evolutionary advantage. They finally link the vertical invader of smell with the topographical sovereignty of sight, crossing forever the metonymy of the spectral gaze and the materiality of smell.

And the old modernist nose? That is left on the virtual face as an ironic reminder of a failed twist of bodily evolution.

Looped History

Looping is the historical consciousness of the liquid self. No longer is history viewed as a privileged finality, but as an indeterminate recycling of media rhetorics. Here, history is finally digitalized, capable of endless sampling, cloning and transcription. Looped history, then, as the recombinant past of the liquid self.

Think of CNN with its global cycle of fifteen-minute news loops, each a small accretion of sampled news scraps that horizon the television day. Now think not only of the news, but of the whole violent apparatus of media entertainment that

functions ideologically by scanning the cycle of human emotions for looping possibilities: nostalgia, fear, terror and joke loops. Looping is the key to the noise of the media, to its dynamic force field within culture. This noise is not background static, but a mediascape that operates formally by ceaselessly repeating the same metaphor, but with shifting (recycled) metonymy.

Looping is characteristic of speed-reading history. As a scanner history it can be spliced, transcribed and cloned according to the controlling metaphor. In this case, patch into the nostalgia code, and recombinant TV history is brought under the sign of cynical sentimentality. Dial into the fear loop, and semiurgical history is speed-shifted to high anxiety and insecurity. Insert the joke loop into the network of the recombinant body and the history of the liquid self is replayed as hysteria.

Roland Barthes once said that "endless repetition" is the dominant ideological form of the social. To this I would add that repetition operates by the technical strategy of looping, complete with cross-fades and partitioned subjectivity.

Displacement as Shock-Wave Violence

Recombinant ears have a great advantage. They actually hear the virtual sounds of booting up and downloading data. Not only for hearing, recombinant ears can also change speed, suddenly shifting velocity as shock-wave sounds are propelled across the dark immensity of the space of virtual sound. Better than their ancestral origins in human ears, recombinant ears can arm their controlling telemetry with the displacement command. Here, pitch and tempo are co-extensive in the grand unified

theory of digital sound. Drive sound down one octave and it approaches inertial drag. Displaced to a lower octave, sound is virally infected by the violence of reentering the atmosphere of gravity waves. It groans, warps and wails in a slow-motion vector of mutating sound waves. Accelerate sound upward two octaves, and it achieves terminal velocity. Here, the human voice is indistinguishable from a saxophone, and can be *triggered* at the same rhythm.

Displacement is also a key mutation in the personality of the liquid self. The psychology of the recombinant body has vectoral coordinates of pitch and tempo. Here, cybernetic personality can be pitched upwards and downwards, accelerated and suddenly braked. As in *Terminator 2,* perfectly instrumental and loyal only to the law of speed, the recombinant psyche is a dense matrix field, adjusting its phenotypic responses to the chemical ocean of data within which it swims. Consequently, liquid psychology emerges as a new psychoanalytic field where the ego finally learns to vibrate as a sound wave. What is the sound of the recombinant ego? A metallic high-pitched scream or a low drone to infinity? Or both? What if the recombinant ego suddenly disappeared into a wave form? It would become a psyche that could orbit its former body as a spectral trace of virtual sound. And if the ego could be displaced into the position of a satellite sound-function, then could we not also talk of schizoid noise? What if the previously interior world of psychoanalysis suddenly took on the auditory form of digital sound, and psychological tendencies could be mapped by their mathematical coordinates of pitch and tempo, and then displaced? A whole field of psychological mutations of sound waves could be radically displaced across the virtual space of the recombinant body.

Of course, all of this has already happened. The media is a vast mathematical field fusing psychosis with sound and im-

ages. We always vibrate in an externalized world of digital psychosis. Displacing our minds in a world of shock-wave violence *is* our (recombinant) personality.

The Computer Has No Memory

Borges again (*Fures Memorias*): A person who cannot forget a single thing, and thus is incapable of a single creative thought. All memory is no memory. Remembrance is also forgetting.

Similarly, the computer has no memory, if by memory we mean the presence of political judgement and aesthetic reflection. Perfectly recalling everything in the cold language of data, it is incapable of the act of forgetting so necessary for mediating politics and history. In this case, computer memory is always cynical, always about the actual disappearance of embodied memory and the vanishing of aesthetic judgement. Data is the fatal horizon of that stubborn presence we call human memory, which is very ironic since memory is the first sampler machine.

Like a combinatorial liquid, human memory operates like a time interceptor, sampling and resampling genetic sequences from the past. Historical time, whether public or autobiographical, has no necessary meaning other than that of a fictional unity onto which are inscribed all of the dominant cultural signs: from the will to nostalgia to the ideological reinvention of the American self. Working in the biological language of cloning, transcription and basal sequencing, the will to memory also serves as a retrovirus sampling the recombinant body of time. As the world's first sampler machine, memory has always functioned like a sequence tag in recombinant genetics, shuffling and reshuffling the random genes of time passing.

In sampler music, a third stage in the evolution of memory is achieved. Beyond the primary phase of *natural* memory (that is data toxic) and beyond the secondary stage of *telematic* memory (which operates to abolish history), sampler music creates the conditions necessary for the appearance of *bimodern* memory: a flashing memory sequencer combining the spectral speed of data sequencing with the contemplative distancing of aesthetic reflection. Working simultaneously by the doubled aesthetic strategy of frenzied immersion (in the liquid media archive) and critical distancing (from the euphoria of techno-logical fetishism) to fuse a past of total sound recall with aesthetic choice by android processors, the bimodern memory of sampler music is what human memory always aspired to (but could never achieve) and what the digital world of computer memory finally forgot to forget. Sampler music, then, as a new ecological relationship between the primary scene of human memory and digital implants.

In sampler music, we revisit the territory of remembered objects, but in a distorted way. A machinal memory sequencer can put aside for a moment a succession of sound objects, which can later be retrieved, resumed, or abandoned. A floating world of liquid memory, working by the irreal rules of radical juxta-position of unlike sound objects, dumps *speed metal* into the inertial gravity waves of slow funk. Here, music is always simulational, always a placeless zone of forgetting and retrieval, of drifting among the stellar wreckage of our human past. Neither pure machinal memory, nor an unmediated product of human memory, sampler music is all about the externalization of memory as a sampler machine. Neither "self-actional" (sampler music refuses technological determinism) nor "inter-actional" (sampler music is necessarily post-referential), the digitally coded and processed world of sampler music operates a new type of space—*transactional space*. This is a space where machinal memory refers to a single human process that mediates cultural

objects (sound referents), social relationships (the interpretive gesture of the composer), political judgement (the dual aesthetic strategy of full aesthetic immersion and critical distancing), and economy (digital simulation).

Crash Art

What is art in the age of high energy physics?

No longer can art be situated within reflection theory, nor can art function as a critic. Art is now a quantum fluctuation: a phase shift where all the old classical certainties dissolve, and where everything can finally be uncertain, probabilistic, and indeterminate. Outside time and running across multiple spaces, art can finally become a violent edge, a space for the cancellation of all the big signs of modernity and for their immediate reversal into their opposite sign-forms. Quantum art, therefore, as that point where the artistic imagination actually becomes the uncertain universe of which particle physics could only dream.

Art, then, as a quantum singularity in which all the energies of the black hole of America fold back upon themselves, concentrating with their energy, until it pulses and implodes. Here, art is a culturelab for working out the inner laws of physics, technology and power.

Art becomes interesting only when it does not exist except as a sign of its own liquidation. A manic art of dispersion and retrieval that marks the dissolution and cancellation of the social field. A quantum art that moves into sonic over-drive, actually dissolving into a detritus of acceleration and infinite speed.

Lycra Sex

The dance club scene as a microphysics of digital subjectivity.

Lycra sex, ecstasy consciousness, music cut to the speed rhythms of smart drugs, vibrating bodies as the outer simulacra of drum machines, and black lighting for eyes moving at shutter speeds. There are no bodies in the dance clubs, just cold seduction and digital sex. Some are all a semio-organ, others a disembodied ear, or entirely an ecstasy head. A sound and light kingdom of suburban decadence, the club is where all the axes of power converge: discourses of sexuality (fear of AIDS requires no-contact dancing), advertising (designer bodies), and crash music. Crash clubs are where sensory overload breaks down the body's immunity, and then suddenly ejects its participants at closing time, a quick exit from free fall into the heavy weight of gravity—the real world of the streets.

What if we never exited from free fall, never ruptured the boom of the drum machines as they fibrillate our skin? What if the orgy never ended? If we never fell flatline from those massive light, sound and smell machines back into the depressing gravity of the real? What if it were suddenly announced that the semio-sex of the dance clubs, with their simulacra of exteriorized senses, was the real world, and that what we had previously mistaken for the real was only a sombre shadow, like the dark and missing matter of outer space, which has no real presence, only an aleatoric apparition of the real? What if the orgy never ended, but carried us away forever and we actually became those pleasurable bodies of seduction, those dreamscapes that we thought we were only imagining? What if the game of cold seduction played by all the dance clubs was the real, and those gravity-ridden streets outside the clubs only a nostalgic reminder of a past and forgotten age?

The participants in the orgy of virtual reality, then, as pioneers of the new world of cold desire and the obscenity of seduction.

"I Am Sick of Myself"

Nietzsche's *On the Genealogy of Morals* is a perfect psychological readout of the dominant subjectivity of virtual reality

> Man has often had enough, there are actual epidemics of having had enough (as around 1348, at the time of the dance of death); but even this nausea, this weariness, this disgust with himself--all this bursts from him with such violence that it becomes a new fetter.

> Where does it come from, this sickliness? For man is more sick, uncertain, changeable, indeterminate than any other animal, there is no doubt of that--he is the sick animal; how does that come about? Certainly he has dared more, done more new things, burned more and challenged fate more than all other animals put together; he is the great experiment with himself, disconnected, insatiable, wrestling with animals, nature and God for ultimate dominion--he, still unvanquished, eternally directed towards the future whose own restless energies never leave him in peace, so that his future digs like a spur into the flesh to every point--how can such a courageous and rightly endowed animal not also be the most imperilled, the most chronically and profoundly sick of all animals.

> I only wish I were someone else, sighs that glance; but there is no hope of that. I am who I am: how could I ever get free of myself? And yet--I am sick of myself.

<div align="right">

F. Nietzsche, *On the Genealogy of Morals*

</div>

ORGANS

WITHOUT

BODIES

3

ORGANS WITHOUT BODIES
The Liquid Ideology of Virtual Reality

The Electronic Cage

Spasm is about our violent descent into the electronic cage of virtual reality.

A floating world of liquid media where the body is daily downloaded into the floating world of the net, where data is the real, and where high technology can finally fulfill its destiny of an out-of-body experience. A virtual experience, we finally enter the dark outer galaxy of the electronically mediated body. Not the Milky Way, virtual experience is the expanding universe of digital reality, with its spiralling arms, teleonomic logic, infinitely curving space, warp jumps, and multiple (bodily) time zones. In recombinant culture, the electronically mediated body comes alive as our android other, complete with digitally enhanced hearing, floating lips, looped history, sequenced sex, and a super-scan memory function.

Max Weber, the German social theorist, might have once prophesied that twentieth-century experience would witness the gradual unfolding of the "iron cage" with its "specialists

EINSTEIN'S

CHILDREN

without spirit," but that dark intimation has already been eclipsed by our descent into the electronic cage of virtual reality. This electronic cage is driven by specialists fiercely possessed by the vision of technology as freedom, which can be so seductive because of the promise of a fantastic extension of the range of human (electronic) experience.

In the electronic cage, we are frenzy, Einstein's children who have always lived virtually. Just as we can never really recover Nietzsche's unmediated sense of the death of God (in our hearts), we have also never had direct knowledge of a (natural) world outside the electronic frontier. A generation born already post-historical in the white heat blast of atomic warfare, we can only understand technology as freedom because for us the language of technology—fractals, holograms, brownian motion, chaos theory, smart drugs, data uplinks—is coeval with our identity. Technique is us, and for just that reason it is difficult to think outside of the electronic horizon that envelops us, to consider, that is, electronic technology in its doubled sense as freedom and degeneration.

Technology as degeneration? The electronic cage corresponds to four orders of domination: beyond alienation (the objectification of the subject) to reification (the subjectification of the object), beyond reification to simulation (the fetishism of the spectacle), and now beyond the age of simulation to virtual experience (the specularity of the fetish). Beyond, that is, the simulated order of the social to the digital order of the virtual, beyond the semiology of the sign to the language of recombinant genetics, beyond the normalizing discourse of sociology to chaos biology, and, most of all, beyond technology as commodity or icon to virtual reality: that momentous evolutionary rupture wherein technology assumes a living species existence, substituting its own genetic logic for the heretofore ascendant genetic history of the human species.

What is virtual reality? It's the fetish of specular culture made real by the fusion of recombinant biology and cyberspace. And what is the fate of the virtual self? A purely aesthetic one. Disappearing into its own trompe l'oeil, the electronic vortex of the floating self is finally liberated of (fixed) identity, of (determinate) gender, of (localized) history, and of (bodily) subjectivity. An electronic trompe l'oeil, where virtual reality means the triumph of illusion, virtual experience involves the aesthetic redefinition of the order of the real, while the virtual self, an android processor, vanishes down the electronic highway from nothing to nowhere.

Maybe we are already living in another dimension of space travel: in a sub-space warp jump, a virtual reality where we can finally recognize that we are destined to leave this planet because we have already exited this body. Not simply the violent expulsion of the body from the weight of earthly gravity into galactic space, but the development of microscopic gene astronauts. Colonies of genes, which once might have fled the primeval soup of the ocean and taken refuge in the geological structure of crystals, the chemistry of plants, then animals, and finally humans, but which now warp jump from the human body into the galaxy of virtual reality. This is a time of primordial genetic rocketry in which genes suddenly are accelerated into orbit around their previous liquid station in plodding human bodies. A new stellar history of TV genes, recombinant shopping, war meiosis, gene nostalgia (what molecular biologists call *inversion*), and advertising mimesis is at hand.

And why shouldn't genes go cybernetic? They have always existed at the forefront of virtual reality: mutants, replicators, cloning, viral genes. Perhaps we have already moved beyond the first stage of the exteriorization of the human sensorium—the externalization of the human nervous system—and are now entering the second, and more decisive, phase which consists

of actually flipping the body inside out: the exteriorization of human genetic history. In this case, technologies of communication would be the means by which genes escape their long evolutionary imprisonment in the body, and inscribe themselves in the labyrinthian electronic highways of recombinant culture. The primal gene, therefore, finally prepared to abandon its evolutionary home in bodily chemistry, to fulfill its destiny by going virtual.

The New World Algorithm

Maybe virtual reality has always been about the mass emigration of genes from the old world of the human body to the new world of digital reality. A new universe of recombinant culture is proliferating where space means computer sequencing, culture refers to hybrid media constructs, the body becomes protein for the system, and power a battle between dominant and recessive electronic genes. In this universe, change occurs by the molecular displacement of warring electronic networks, and time is rendered virtual by computer programmes for time-stretching and time-condensation. Not a static reality, but a dynamic one. Here, recombinant sounds follow virtual parabolic curves across the deserted terrain of the spastic body. Mutant images of the new world algorithm float across the mediascape, and recombinant drugs harmonize the mood sensorium with the ecstatic chemistry of virtual technology. Complex algorithmic equations take flight from mathematics, reappearing in the disguised form of digital sound, images and smells.

Virtual reality, therefore, as recombinant culture. Recombinant culture becomes a technical term for the mutation of genetic history into the language of mathematics, a purely algorithmic world under the regulatory control of the universal

mathematical sequencing project. A floating, spatialized world where reality is reconfigured into a dense algorithm, where bodily identity can be tracked at the spikes of the X and Y axes of digital sound waves, where the algorithmic face acquires organicity in the real world of TV, where digital music is all about travelling at warp speeds across the valleys and peaks of sound algorithms, and where the white space of all the electronic communication networks rapidly descends into the inertia of world cultural gridlock. A digital reality that now acquires tremendous social acceleration, moving at a violent speed towards a great algorithmic convergence: that point where the complex strands of human genetic history are reduced to the telemetry of a single dense algorithm. This algorithm encodes in its programming the final legacy of recombinant culture: the fatal combination in the new world algorithm of the operational logic of data generation, sequencing, cloning, and transcription.

The *new world algorithm*? That is, the merger of recombinant genetics and virtual reality into the horizon of contemporary culture. Neither purely biological, nor simply mathematical, the new world algorithm insinuates biology into the language of hyper-mathematics, and reorders biology by the virtual dimensionality of algorithmic logic. Consequently, the new world algorithm is produced as a spectacular launching site, not only for the dominance of bio-technology as the contemporary language of power, but for the very first dimension-jump. Such a jump signals the moment at which recombinant technology disconnects from its earth support systems, becoming self-sustaining in the space of bio-mathematics. Consequently, virtual reality, which comes into existence through the recombinant language of genetic biology, is set into motion by the algorithmic logic of mathematics, and takes the android form of organs without bodies.

What is the fate of the body in the recombinant culture of

virtual reality? Like crystals, plants and animals before it, it becomes genetic refuse. Having fulfilled its evolutionary function as a chemical way-station in the development of genetic history, the body can now be discarded as surplus skin. But with this difference. The final product of genetics—intelligence, the very medium by which humans prepared the algorithmic orbital stations for gene travellers— also condemns us to consciousness of loss. The human body, then, as a sacrificial scapegoat preyed upon by the primal gene for its evolutionary purposes, and then abandoned as anthropological debris. In the dark space of virtual reality, in this universe of organs without bodies, the human body floats like a chemical afterimage, with no purpose (the body is a terminal function), no final destiny, and no (evolutionary) role beyond that of a predator flipped into a useless parasite. Perhaps the last function of the body is to be sequenced as data: to be shuffled and reshuffled into sinewy nucleotide chains having a threefold biological logic: self-replication, quick adaptation, and chemical (media) cloning. The recombinant body, therefore, as a molecular sequencer in the ganglia of the mediascape: sometimes combined into an eye when TV genes sweep to cultural ascendancy, sometimes mutated into an ear when sound alleles gain genetic dominance, and at other times aimlessly shuffled into chemical chains of embryonic cultural matter.

Organs without Bodies

Spasm is a libidinal descent into this sea of liquid media populated by organs without bodies, a world of robo-theory, machine sex, virtual reality, electronic TV fibrillation, surveillance scanning, and recombinant culture where our bodies migrate daily, and especially nightly, to be processed

and re-sequenced. A seductive descent of the body where the flesh flips open, and out fly all the previously hidden codes of human genetic history on their way to a fateful meeting with recombinant technology. Maybe it is no longer technology, as much as an immense galaxy of android genes finally coming alive and taking possession of us. And we adore it. For this is not a passive world, but a violent one: a universe of sacrificial violence, and *we* are its willing practitioners; a world that promises maximum information, wealth and mobility, but actually produces radically minimal understanding. Not a new universe of mass communication, but a society of alienated masses, radically independent of others, but uniformly dependent on elite command centres.

A cold and antiseptic world of techologically constituted power where virtual experience means the sudden shutting down of a whole range of human experiences. Not really a new virtual world, but a fulfillment of the more ancient phallocentric dream of recoding experience with such intensity that the body floats away from itself, and in that universe of digital impulses finally alienates itself from its own life functions. Virtual reality is the exteriorization of the human genetic apparatus with such speed and violence that the body finally becomes its own techno-skin.

Consider the cinema, which is, after all, how virtual reality is first innoculated into the system of liquid media: a site of low epistemological profile but mass emotional appeal. It provides an already superceded electronic travelogue concerning how we have learned anew how to swim in the sea of data. And if we flock so eagerly to the cinema of virtual reality, it is because we have long ago recognized ourselves as mirrored images of special effects, spectral personalities floating within liquid media: data workers, practitioners of sex without secretions, floating tongues, memorex minds, and fax hearing. Consequently, we

42

can participate so enthusiastically in the crash cinema of *Lawn Mower Man, RoboCop* and *Terminator 2* probably because these are less fateful images of a future not yet experienced, but vague intimations of a past forever eclipsed. For better or worse, we are the progenitors of special effects personalities. Crash bodies always on the hunt for a new techno-thrill. Having long ago sworn off the neurosis of user-friendly technology as terminally boring, we've become frontier riders of a digital reality that always moves too inertially for our long-suppressed taste for the forbidden pleasures of telematic speed. We are on the hunt for abuse technology, for digital gear that can be strapped on or swiftly patched into our neural networks. Crash gear that will allow us to arm the liquid media, and trigger a dizzying array of special effects experiences.

Crash Aesthetics

This may be our political predicament: to be simultaneously a new human race of techno-mutants in the name of an expanding freedom, and critics of technology as degeneration. If this appears ambivalent, it means that all comfortable modernist exits for ethics and politics have been cancelled out, forcing us to travel in hyperreality at crash speeds without the guidance of traditional ethical suasions. While we can recognize the dark truth in Nietzsche's prophecy that ours would be a time of revenge-seeking nihilism, either by the majority of passive nihilists or by the leading "ascetic priests" of suicidal nihilism, we cannot finally evade his insight into the impossibility of rupturing the closed horizon of technology as the latest, and most grisly, manifestation of the *will to power*. Consequently, our fate now is to develop an ethics and politics of impossibility: a critical politics that would simultaneously insinuate itself within

the command logic of virtual reality, while dislodging itself from loyalty to the violent orb of liquid media. An excessive ethics and politics that would operate under a double sign: appropriation and resistance, immersion and displacement, speed and memory. In short, a *crash aesthetics* that would privilege cuts, disturbances, flips, turns and quick reversals; operating according to the twofold aesthetic strategy of ironic distancing and ironic immersion. A crash aesthetics that privileges excess because it seeks to *overload* the electronic frontier, to bring the universe of data under the fatal spell of the violence of speed.

And why not? Crash aesthetics is SONY from hell. It's about writing a new high-ethics language for the hyper-modern body, where the body is software to the hardware of the liquid media. Not like jacking into cyberspace where the body is left behind, the crash body, the *recreated* body, runs interference in the culture of maximal speed and power. Crash aesthetics is about the recuperation of the body, morally rearmed, technologically fit for riding the envelope of high-tech into the crash zone. The crash aesthete is fully equipped:

*recombinant ears with amplified hearing for editing
 sampler culture,

*new skin for swimming in the ocean of telemetried data,

*techno-gills in the form of patches for breathing in the
 air of cyberspace,

*improved tongues for tasting liquid reality,

*and scanner eyes for a culture of body parts.

Crash aesthetics refuses use-value technology of the old modernist tradition. It demands quick and intellectually complex technology for bodies moving at terminal speed: user-abuser machines. Here, technology is forced to undergo a fatal acceleration, to patch into a newly evolving body type—*crash bodies.* Crash aesthetics, then, are for people who *demand* the special effects of creative freedom in the world of virtual reality. They don't fight crash, but demand the vertigo of the crash experience where you're finally riding the outer edge of speed culture. So, the next time someone says "user friendly," strap on your crash technology and see how fast it will go, how it tastes when you fly technology at sub-suicidal speeds, how virtual reality actually sounds, how the body melts down as it is dipped in and out of the force field of the liquid media.

Crash aesthetics, therefore for fast circulation in the age of special effects. The purpose is not to confirm the inevitability of our transformation into the matrix of virtual reality, but just the opposite: to introduce into the closed horizon of the discourse of digital technology a minimal level of disturbance and interference, a threshold level of background static by which to rupture the sealed universe of the liquid media. That is, an aesthetic strategy that seeks to understand what has happened to us in digital reality by developing an ideomatic language for sampler technology. To actually *listen, see,* and *feel* our way to a critical cultural politics that would act as a partition-point between ironic distancing and critical immersion in contemporary society. And to do this via an aesthetic strategy that functions parasitically, probing the world of digital sound and imaging with such violent intensity that the principle of parasitism flips into its opposite: the recreation of the ethically enhanced and technologically intelligent body as the advanced forward edge for intercepting a digital reality that threatens to suffocate us with the charisma of its seduction.

4

CYBER EARS

SPASM *is speeding down the throats of all the android processors.*

In the age of virtual reality, the traditional sovereignty of sight over sound undergoes a big flip: the image-simulacrum begins to slow down, and to act as a technological drag on the speed of virtual reality. Requiring for its very existence an amplified memory structure, the image-reservoir of computer graphics begins to substitute its own imperatives for the violent speed of virtuality. The computer image-reservoir achieves its final destiny as a big capacity resistor, slowing down all the circulatory networks of digital reality. In virtual reality, sight always moves to inertia.

But not the world of sound. Needing little in the way of computer memory, digital sound can finally come into its own as the expanding envelope of virtual reality. Here is where all the experimental breakthroughs are being made in understanding the unfolding cultural logic of technological society: looping, partitioning, layering, panning, aliasing, filtering, mutating. Listen to the sounds of virtual reality, therefore, to discover the speeds and slownesses, the breakthroughs and breakdowns of the world of digital technology. The demand

for an enhanced sound cranium finally fulfills itself in a sampling technology that swiftly flips music composers into android processors, alllowing MIDI computers to break their vows of silence, to tell us personally what music machines have been thinking about all this time but have never had the opportunity to say. Until now, sound has usually been in the background. Digital music is different. It foregrounds sound by making problematic the energy field of noise, reenchanting the ear and projecting complex sound objects outwards into imaginary shapes, volumes, and liquid flows.

The ear finally comes into its own. But not the old ear attached to a living head. That has already disappeared and no one cares. We are now living in the evolutionary era of improved eardrums, of cyber ears for spastic sounds. If digital music is to be appreciated, there is an urgent necessity for the development of algorithmic ears: for eardrums that can hear sounds that do not yet exist, and that can never be replicated by the human voice. Consequently, what is necessary is not the recovery of the ear as a privileged orifice for the nostalgic return of oral culture, but the growth of new ears—digital ears—as a sign of nostalgia for the future. The bio-technical ear, that is, operating at the level of the sub-human, splaying outwards across the mediascape, afloat in the digital world of virtual sound.

Anyway, sampler technology is the forward mechanism of late capitalist culture. Working parasitically by appropriation, it mimics perfectly the acquisitive tendencies of technological society under the sign of the private commodity form. Operating at the level of digital sound, not sight, it envelops us in a massive soundscan that vocalizes the codings and recodings of the body telematic. Here, all of the hidden strategies employed by technological society in sampling human beings—of their memories, desires, fantasies, and needs—are worked out in brilliant detail. When we listen to sampler music (and what

music is not digitalized today?), we can actually hear our approaching fate as we are sampled for our history, dreams, and destiny. Consequently, think of the computer commands for the digital manipulation of sound as an exact ideological code concerning how our subjectivity is processed by virtual reality. *Looping?* That is, the ceaseless inscription of semiological tracks of personality, facial redesign, body sculpting, memory massaging. *Filtering?* That is, the movement of the previously aesthetic strategy of the trompe l'oeil beyond painting into the mediascape, that point where every action is only understandable by mirror references to its cultural code. And *panning?* A war strategy designed by the mediascape that submits the brain to multi-directional tracking: of its preferences, likes and dislikes, points of nausea and ecstasy. An encryption machine for understanding the ideology of advanced capitalist society, sampler music technology both deciphers the inner semiurgical rules of the mediascape and provides a method of transgressing a culture where simulation *is* nature. Digital sound, then, as an advanced outrider of the ideology of the mass: an eight-second waveform with ninety-one minutes of sampler memory. Having no real presence, the digitalized mass exists only as an optically charted wave function. Capable of infinite manipulation, the volatile wave-form can be massaged in the same way that android processors (computer music composers) look for the best spikes at the XY axis. Just like virtual sound-objects in sampler music technology, subjectivity today is a gaseous element, expanding and contracting, time-stretched, cross-faded, and sound accelerated.

Writing the History of the Cynical Ear

The repressed ear? That is the fate of hearing in the age of virtual reality: a whole cultural image machine which privileges the eye, and that simultaneously shuts down the ear. And why not? The eye is a masochistic orifice in the age of panoptic power, capable of endless discipline and of being seduced beyond bodily subjectivity into a floating free fall within the society of the spectacle. Public not private, spatial not durational, the eye is always a possible traitor of its human subject, always tempted by the siren-call of the dialectic of enlightenment to make its peace with the scopophiliac apparatus of cynical power. And it must be so. For the eye has a penis. It is a privileged organ of the male sex: space-binding not time-binding, hierarchical not polysemic, mechanical not fluid, signifying not subjective. It is precisely the opening up of the eye of cynical power which shuts down the consciousness of embodied subjectivity. We live, then, in the time of the cynical eye.

If the ear can be so stunted today, if hearing can only be accomplished through the medium of the specular, if music today must be mediated through the imaginary overdrive of MTV, it is because everything now functions to repress the ear. For the ear is politically dangerous. This is the organ of the feminine: of a possible sex that ruptures the silence of the eye with a babble of bodily fluids and that in the act of listening rehearses the recovery of bodily memory.

Or maybe it is neither. Not the masculinist eye with its privileging of specular power, nor the feminine ear with its lament for lost subjectivity, but something different: the mutant ear as a site of arbitrary sign-shifts for the body telematic, half-skin/half-code, which shimmers like a time-shifter across the

surfaces of sampler culture.

Consequently, the imperative emerges for writing a history of the ear. Not of the natural ear (which has vanished with the appearance of simulation), and certainly not of the discursive ear (listening is no longer limited by the grammatical rules of semiology), but the history of the cynical ear.

The cynical ear? That is how our ear flashes across digital reality. Neither the old biologically-driven ear lost in nostalgia for aurality nor the recombinant ear splayed indefinitely across the mediascape, digital hearing is the degree-zero point for the mediation of biology and algorithmic recodings. Finally then, the modernist history of the ear under the fatal aesthetic sign of referentiality can end, and the postmodern story of the exteri-orized ear under the ecstatic sign of recombinant genetics can be refused. In this case, a third hypothesis can be negotiated: the cynical ear as neither modern nor postmodern, but *bimodern*. Bimodern hearing is a partition-point between (bodily) memory and (digital) reconfiguration, between listening for "intima-tions of deprival" in the midst of the technological dynamo and hearing the future sounds of the reconfigured body. Which is to claim that the cynical ear — bimodern hearing — is nothing less than a third evolutionary stage in the history of the ear. Beyond unsignified biology and disembodied simulation to the aural hinging of genetics and data. In bimodern hearing, the ear is endlessly recoded by *culture sounds* as a way of recovering an aesthetic strategy for digital manipulation in the age of android processors.

A philosophical history of the bimodern ear can only be written in the shadow of ambivalence and ambiguity, for it concerns two impossibilities: the recovery of memory by learn-ing a new method of algorithmic hearing, and the opening of a new horizon of listening through a digital reality that seeks to

displace the ear. Consequently, an impossible writing. A writing that rebels against the ruling order of the eye, only to seek out the excluded territory of the ear. And a history of the mutant ear that claims that the biologically-determined ear has disappeared to be replaced by a recombinant ear. The digital ear, first existing at the folding back of biology into data, can already be at the dark and unexplored side of virtual reality, because it can hear the silent shuffling and reshuffling of data in sampler culture. A sampler ear can listen to the sounds of virtual reality as a way of tracing out in consciousness the mutation of the bimodern body into that which it always thought it was only listening to: cyber sounds, waveforms, volume swells, partitioned subjectivity, looped brains.

We live now in the age of recombinant culture, where the previously private genetic structure has gone public and is played back to us in the form of data. An algorithmic world where data has come alive and in its endless codings and recodings we can discover our fatal destiny. A prosthetic world where sound appears only in the form of aural trompe l'oeils: virtual volume, velocity, pitch, and rhythm. An auditory space of illusion that is inscribed as the dominant locus of our social space. Not panoptic space (there is no longer a stable eye of surveillance), nor representational space (virtual sound is already beyond the governing episteme of the model versus the real), and not even simulation (today even the model is cybernetically generated), but an autonomous space of illusion. Sleights of ear, mirror shifts of sound, waveforms, sound warps, phasal noise: this is the illusional space that marks the imaginary territory of the digital ear.

Which leads to the question: what is the space of virtual sound? the response must be: the sounds of the trompe l'oeil, that virtual space where sound has no (referential) existence except as a sign of that which never was: sampler sound. And

why not? Sampler music is its own simulacrum. It knows no originary referent because it generates its own territorial codes for the mutant ear. It is always hyper-mimetic because it can exactly reproduce (and swiftly surpass) any sound in the human sensorium. Sampler machines light up the previously dark region of virtual reality. Not passively, but following an experimental strategy that explores at the level of sound what has happened to us as we have been processed through the virtual world of technology. The work of sampler composers (from Australia's *Severed Heads* to Amsterdam's *Ministry*) and sampler technology as artistic filters trace the migrant journey of the crash ear. A brilliant political theory of the ideological constitution of bimodern subjectivity (the filtered self) and an aesthetic strategy for reterritorializing the specular space of virtual reality (digital manipulation in the age of android processors and recombinant culture) is to be found in sampler music. In such works, the ear rebels on behalf of improved hearing.

Improved Hearing

To tell the truth, hearing has always been alchemical, a violent zone where sound waves mutate into a sedimentary layer of cultural meanings, where historical referents secrete into contemporary states of subjectivity, and where there is no stability, only an aural logic of imminent reversibility. The cynical ear makes alchemists of us all: primitive physicists who know that sound does not exist except as an empty zone of energy exchanges. Our legacy? An entire history of bimodern sound theory: sound waves/sound particles as the theoretical antinomies of an early twentieth-century discourse on sound, which anticipate the logic of contemporary cultural experience.

Anyway, we are already living beyond simulation (where the model generates reality) in a more spastic experience: the society of the waveform (where the model vanishes into the recombinant language data genomes). Sampling, therefore, beyond alienation (which seeks to preserve the order of the real), beyond reification (which privileges the stability of the ruling concepts), and beyond simulation (where the concept is the real itself). A culture of quantum fluctuations where you can only know that you have never seen what you thought you were looking at because you have never really heard what you were listening to.

The pre-digital ear is the first victim of sound trompe l'oeils: from the virtual sound of Madonna Mutant to the virtual body of Michael Jackson. So then, an urgent requirement emerges to speed up the ear to match the aural velocity of digital reality, to pump up the genetics of hearing to equal the sounds of the datascape. Sampling technology, therefore, as a filter for mutant eardrums: looped ears, partitioned hearing, panned sound, accelerated eardrums, time-stretched sound, digit design ears. In the materiality of sampling we can discover anew a language for rethinking a universe that has been blasted apart by digital technology. Consequently, the education of the cynical ear can be an aesthetic strategy for learning how to cohabit the planet with android processors.

AESTHETICIZED
RECOMMODIFICATION

Aesthetic Strategies for Digital Manipulation in the Age of Android Processors and Recombinant Culture

Why not music in ruins too? Crash music. A cynical sound so intense, so much a spectral commodity, that like a dying red star it implodes with all of the dark intensity of a force field of pure inertia and pure speed, passing through all of those drifting cyber-bodies. Crash music? That is music as a universal force field of sound that can be so seductive because of its fascinating logic of an always promised imminent reversibility: pure ecstasy/pure catastrophe. Music, then, with no past, no (determinate) meaning, but perfectly defining, perfectly energizing, perfectly postmodern.

Crash music, therefore, for the body without organs
for sex without secretions
for flared eyes of the body telematic
for smells without a rotting skin
for neon ears without skulls

Music Rules

Like advertising, fashion, and cinema before it, music rules today as a dominant ideogram of power. Not a reflection of a serious materialist power which emanates elsewhere and that precedes it, music is a real ruling laboratory of the age of sacrificial power. We are living today in the triumphant but desperate era of aestheticized recommodification. The simulational age of designer subjectivities where the commodity-form most of all needs to be aestheticized to ensure its endless circulation through the debris of all the seductive

objects of consumer culture. Here, music as an empty force - field through which all the fibrillated subjects pass, lends a momentary coherency to a system of objects that always threaten to collapse in the direction of entropy and burnout.

No longer only a simulation, music is now the key code of the postmodern body as a war machine. Music, then, as a force field through which processed subjects pass, with its privileging of pure speed, of sound approaching the velocity of light; with its vectoring of random subjects across a keyboard of outered emotions; with its inscription of the codes of frenzy and desire onto the body without organs; and with its fatal promise of pure inertia when the sound switches off and all the dancing bodies collapse. It is how postmodern bodies speak to one another, how they collude, conspire, and seduce. Here, the internal rhythms and grammatical codes of the war machine are transcribed into auditory codes that can only be seen with the ears and heard with the eyes.

And so, an interesting question arises. What is the relationship between the inertial grammatical codes of postmodern society as a war machine and the acoustical sounds of music? Crash music is not as much a representation *en abyme* of particular phases of culture, but it is one of the real world of political economy. Crash music exists as a culture smasher, a cultural cyclotron, in the era of crash economy. Which is to say that culture is not a reflex of political economy, but that society is now a reflex of key shifts in music theory and practice. Music rules in the quantum age because sound moves faster than the speed of light, thus quickly eclipsing history. Study music theory, then, as a laboratory of big transformations in power and economy. They will all have their punk period, their sampler phase, their house music era, their heavy metal economy, their rap aesthetics for the commodified body.

And how does music serve as a laboratory of sacrificial power? In three ways:

First, by its cultural code, where music serves to energize the dead and inert social field, replacing the history of the social body with nostalgia for a romantic invocation of the culture of sound.

Second, by its method, where, when the energy is turned on, music as a force-field activates the social in ruins, and then, when the energy switch is flipped off, the imminent catastrophe promised by postmodern culture finally occurs as the sound fades away into the disintegration of time.

And finally, by its presence as a cynical sign, where the representational phase of music exists only as a nostalgic sign of that which long ago ceased to be: the age of power with a real referent; of capital under the sign of use-value; and where if the real tactile bodies of musicians disappear into the simulational order of drum machines and samplers, it is because we are living now in the era of abuse-value, where music is interesting only when it is purely cynical—an empty sign of that which never was.

5

SPASM: THE SOUND OF VIRTUAL REALITY

The Recombinant History of Western Music

Spasm: The Sound of Virtual Reality is digital dream music for android outlaws in the twenty-first century.

Crash music for life on the express lane of the liquid media. Here all the old bodily orifices are set aside for a moment, and the digitally encoded music body takes over featuring telematic ears for improved hearing. History becomes an endless retrieval and reconfiguration within the museum of sampled sounds, floating voices, partitioned bodies, and radical disjunctures: crash noise where Gregorian Chant meets *Severed Heads*, and opera rubs against heavy metal,

Listen intently to this music and you are suddenly swept away into the spectral future of android intelligence: what they think (speed to the max), how they think (phasing and rapid partitioning), who they think about (sound as throw weights), and where they think (sampler culture). A perfect sound image

of android culture: this is a sampler society where reality is accessed algorithmically, entered, stored, and disappeared digitally; the content of which is a vast labyrinthian archive of found sound-objects, from the metallic clanging sounds of closing doors on subway cars, to splayed operatic voices and Madonna Mutant. Not a passive world, but an active and intensely creative recombinant one, where the traditionally privileged role of the composer is fast forwarded into a machinal apparatus (with the Akai S-1000 digital sampler as the android composition machine of choice), emerging in the recombinant form of an android processor.

When the liquid machinery is armed, a hyper-charged energy field is created in which the history of western music is suddenly touched by the elemetary particle of charm. Western music goes recombinant. It is suddenly uplinked into a starlight horizon of a thousand billion data bytes, becoming a malleable object. Not a sound-object, that's too hard-edged, formalistic, and mechanical, but more like liquid sound, where noise melts down into a fluid, viscous material, endlessly combinatorial, following an indefinite curvature of violent velocity. We might have entered this universe of charmed sound through Duchamp's famous "gateway," through his brilliant mind plays with illusion and anamorphosis, but when we launch into the universe of recombinant music we have suddenly disappearared through Duchamp's gateway, and what he could only do by way of performance sculpture, we can actually experience sensorially. For what is *Spasm: the CD*, after all, but the android future predicted by Duchamp finally migrating beyond the prison-house of the plastic arts, and breaking into song, becoming a fantastic sound matrix to which our heads are only illusory optical referents? A new architectural space of music appears, what might be called sound anamorphosis, where android songs from *Johnny Mnemonic* and *Aliasing* to *Windows* and *Madonna Mutant*, actually serve as liquid gateways, hinges by

which we can see in undistorted form what we have become in digital reality. In *Spasm: the CD*, understood as the recombinant history of Western music, we finally have a hard-driving, but immensely delicate and configured, auditory instrument for hearing our violent immersion in the liquid media of digital reality. This is Duchamp for the ears: a hinged world of sound-partitions, displacements, aliasing in a process of endless reproduction.

Post-Referential Sound

Certainly not a world of referential finalities, the music hints at the definite termination of all referents. Consider this: before *Spasm: the CD*, we could still talk in comfortable terms about the pedigreed world of sound-objects, each with their own narrative history and enveloping rhetoric. After *Spasm: the CD*, however, the sound-object is actually vaporized, speed-processed into a purely relational process through a violent algorithmic manipulation. What emerges is not nostalgia for the lost continent of the sound-object, but the instant creation in *Spasm: the CD* of the world's first post-referential sound-object: an endlessly reconfigurable sound matrix. And this world of liquid sound turns out to have a very distinct personality. It is a cybernetic pathogen, part-predator/part-parasite, always engaged in a sadistic hunt for unlikely new sound combinations (Renaissance polyphony rubs against *Einstürzende Neubauten*, *Jungle Brothers'* Hip Hop is smeared across a sound background of fast spastic industrial jazz, metallic drones and whining machine drills alternate with the smashing sounds of imploding windows). It is also an android voyager that loves walking in the streets of a dirty materialism, where the noise of sleazomania culture meets the tight-assed, closed-sphincter

tones of the highly-formalized music of high society.

But don't weep nostalgic for the narrative tradition of Western music, for its opera, chants, and symphonies: they've never had it so good. In fact, *Spasm: the CD* is the perfect sound simulacrum. It reinvents the western music tradition in a way that is more real than real, achieving an infinite perfectibility. The android machines have a keen ear for operatic voices and symphonic orchestrations that are telematically perfect in pitch and rhythm. If Mozart were alive today, he would be hard-wired to an Akai S-l000, and would be the first to describe himself as an android processor. And why wait for Mozart? With recombinant sound, we can immediately access Mozart's digital ear canals, becoming Mozart interceptors, coded chips that encrypt the sound simulacrum producing in its wake a Mozart sound world, a Beethoven sound field. And if this theory is correct, not just music, but the whole world could be radically intercepted by a menu of digitally encoded sound chips. Give us the code, and we can have *Grunge* soap operas, *Acid-Jazz* news.

All this is nothing new. Digital technology has always sought out an impossible perfection, a sound matrix of perfect pitch, rhythm and velocity beyond the auditory capacities of the human ear. An indeterminate standard of perfection that mimics Hegel's "bad infinity," where the process can never be finally consummated, but follows the terminal lines of cynical sound. What is really new in *Spasm: the CD*, and what makes of it a definitive rupture with the normalizing, and suffocating discourse of digital reality is that it rubs impurities against perfected sound objects: it privileges the energizing force of the viral sound parasite. Here, parasites are everywhere. They flood the liquid sound matrix: Michael Jackson has to listen to a philo-

sophical critique, John Zorn is forced to race an intrusive computer, William Gibson's *Johnny Mnemonic* is taken all the way, where the body is actually transformed into a flesh of musical notes (where the body wears its sound matrix like a screen of liquid crystal). Sound parasites don't exist outside of the text, but are integral to its logic. They race across the perfect matrix of recombinant sounds, infecting it with diseased noises, forcing it to come alive and confess its secret. The recombinant history of western music is about liquid sound-objects that are purely cynical, that are disappearing zones at the vanishing centre of sliding signifiers.

Spasm: the CD is outlaw music, not simply because it challenges the sovereignty of the capitalist rules of private property (which would make its politics nostalgic), but because it takes recombinant culture on its own terms (*Spasm's* formal compositional strategies represent the advanced theoretical edge of digital reality), and then subverts the process by privileging the previously excluded figure of the parasite. Not the parasite as foreign agent, but the inner telematic parasite hidden at the digitally encrypted centre of every techno-mutant (from *Madonna Mutant*, Michael Jackson and Jesse Helms to Elvis and *Seduction Miserere*), the parasite virus that is triggered not as an invasive agent from the outside, but one that is armed from the inside. *Spasm: the CD* triggers the inner parasite enfolded in the digitally encoded logic of recombinant culture by pushing the process to its extremes, forcing it to reveal its excesses, compelling it to re-energize itself by rubbing primitivism against digitally perfected sound. (The secret ideology of Madonna Mutant is forced to the surface of sound consciousness by a compositional strategy of surplus excess, the inertia at the centre of John Zorn's hyper-jazz is disclosed by straining his music through android smart machines.)

Theory Anagrams

Like atom smashers in the big science of elementary particle physics, *Spasm: the CD* is a theory cyclotron. That is how it was conceived. Each musical text in *Spasm* is a theory anagram, representing a solution in sampled sound to a specific theoretical problem. Android music, then, as a brilliantly compacted and digitally encrypted political critique. Here, Nietzsche's "will to power," Bataille's "excess," and Girard's "sacrificial violence" finally break the silence of print culture, exploding outwards in a thousand recombinant sounds. This is the noise political theory makes in recombinant culture. Encrypt that sound, and one can finally discover the secret political history of an age which splits between the radical intensification of technological experience at its centre and the widespread emergence of unfocussed political rebellion in its margins. *Spasm: the CD*, therefore, as an android *Leviathan*.

For example, the *Recombinant Body* is the highly pressurized sound of the force-field in which techno-mutants live. Here, the human heartbeat is suddenly speed-snapped into the high velocity of android circulation—a dromocratic beat with a techno-mutant rhythm for life in sampler culture.

And why not? *Spasm: the CD* consists only of processed, sampled sounds. It is a perfect hologramic image of the simulated world where history can be instantly reconfigured, memories armed and cybernetically triggered, and even sex launched into a virtual orgy of cynical seduction. This digital world privileges *Johnny Mnemonic* as its dominant model of subjectivity. No longer the world of cyberpunk, but something more excessive. A crash zone where the hard-edged romantic sounds of cyberpunk gear flip into a liquid sound, and we are

left to wander around in the externalized mind of the mnemonic: permanently bombarded by all the sights and sounds of virtual reality, but incapable of differentiation. A digital universe of mnemonic memory circuits, cross-faded personalities, liquid icons, recombinant genes, smart machines, and even more intelligent drugs. Consider, for instance, *Seduction-Miserere.*, It can mimic the inner semiurgical rules of the mediascape because it foregrounds the cut and splice techniques of promotional culture. Not just an instance of sampling the media archive as the content of promotional culture, it displays something more insidious: skip-sampling where random samples (of memories, dreams, desires) are machinally triggered from the digital reservoir.

Digital culture is not a real world, but a purely illusional one, similar to the "phased" experience evoked by *The Accelerated Body.* This sampler text is not about speed at all, but about the slowing down of the body into a fatal zone of inertia. That is what the first and last laugh indicate. They announce *our* disappearance into an illusional space of syncopation: a counterfeit world where sounds appear to speed up, only to immediately implode. Here, a slight phasing in the pace of technological experience (and what experience is not technological) rapidly flips into real syncopation: a world of simulated speed only, where the illusion of speed occurs in the digital reality of an "overdriven sampler sequence." The cynical laugh, therefore, perfectly brackets *The Accelerated Body* because speed and inertia are the mirrored images of digital reality. Or as Virilio said in *Speed and Politics*: "The violence of speed has become both the location and the law, the world's destiny and its destination."

Consequently, *The Accelerated Body* is a trompe l'oeil for virtual reality. Until now, it was never evident what technical strategy was involved in creating the illusion of speed. Now it is: two forms of displacement—*phasing* and *syncopation*. Phas-

ing describes a minimal threshold of distortion that, once introduced, makes it appear that two beats are hitting together, producing the apparent sensation of sound moving at twice its original speed. Accelerated sound, therefore, as a virtual product of the digital strategies of recombinant technology.

To the essential question: Does displacement have a more general cultural significance? The answer is affirmative. Phasing and syncopation are basic cultural strategies in late capitalist society. Phasing? That is the continuous reproduction of the consumer body in slightly distorted form. A culture of resignification that functions by strategies of aesthetic recommodification—the disappearance of the originary value of the commodity-form, and the recirculation of the floating values of the sign-form. And syncopation? That is everywhere. Consumer culture functions as a vast doubling of the body: its desires, memories, and libidinal flows. A syncopated body that mirrors subjectivity in a vast hologram of the social. Consequently, for every virtual orifice an industry of resignification, an image for very abandoned desire, a sound for every disappeared memory.

Spasm: the CD is a spiralling galaxy of warp jumps and violent event-horizons. Here, there are no longer any marked finalities or privileged polarities. Never purely a world of symbolic exchange or binary functionality, but, instead, *Spasm: the CD* is characterized by what Jean Baudrillard has described as seduction: the injection of a minimum element of reversibility and uncertainty into the dense fragments of the universe of referential signifiers. Or maybe something more. A *crash experience* that is postmodern (with radical heteroglossia, and the radical juxtapositioning of pop music icons and formal compositional stategies), but also incorporating a violent metastasis of inertia and speed as its content. The music creates a virtual reality that operates under the sign of an indifferent

implosion: gender warps (*Madonna Mutant*), the sliding signifier of flesh-tones (*Just Take That Memory*), digitally reconfigured tongues (*Elvis' Lisp*), the disappearance of human subjectivity into pedantic automatons (*Nostalgia for the Future*), and ambiguous icons (*Windows/Strata*).

To the question: What is the sex of android machines? The answer is fully ambiguous. In *Spasm: the CD*, voices are severed from their gendered referents. Women's voices are pitched two octaves lower, becoming a menacing, almost inhuman, industrial drone; Elvis suddenly begins to lisp as he mutates into the partitioned body; and male voice samples sign-switch their sexual biographies, sometimes appearing in sonic drag as women and, at other times, as steel-edged macho androids. Consequently, a whole sound universe of virtual voices that have no loyalty to the referential signifier of gender, but co-exist in the uncertainty field of a gender warp. Android sounds, therefore, assume a sexual referent only as a nostalgic allusion to a gendered history that never existed except as a vanishing sign of its own disappearance.

Is the creation by *Spasm: the CD* of a virtual voice a final product of the more phallocentric dream of exiting language from its terminus in biology? Perhaps. In this case, not only the virtual voice but virtual reality itself would be the violently abstracted expression of gender bias, a virtual world for sounds without bodies, sex without a ground, and speech without (biological) memory. Or is it the opposite? Not the virtual voice as the final expression of logocentric desires, but the despotic sign of the male voice as itself a victim of gender warp. In this sense, the virtual voice—the mas/fem voice—would inscribe Baudrillard's thesis on seduction at the level of sound. *Spasm: the CD*, therefore, as the very first of the theory anagrams: a dense nucleus of *sound-genes* that materializes in the warping motion of mas/fem voices an entire virtual universe ruled by

seduction. Not a degendered world, but a new world of bimodern voices. Transvestite voices then can freely mutate their sexual signs, because the referent of sexual biography is already a symbolic sign of that which never existed. Virtual sounds can break beyond the epistemic prison-house of the ideologically constituted (sexual) self—the carceral of an already signified gender—and introduce the cut of a floating sex, the disturbance of a floating gender, the hinge of a floating voice, the imminent reversal of a resequenced lisp in Elvis' *Heartbreak Hotel*. Consequently, *Spasm: the CD* is in the way of a fateful rupture with the space of representationality. Here, ambiguity, liquid icons, and warp jumps are always only a hinge experience, a partitioning of two sexes that would be one (android), and yet divisible.

Resequencing History

Spasm: the CD is a perfect model of the culture of implosion, that culture marked by globalization at the top but fragmentation at the bottom. A violent event-horizon where the radical intensification of the universal power of technology is accompanied by the rapid disappearance of local cultural experience. Life becomes a mediascape where every fragment of the cultural archive, and our subjectivity with it, can be resequenced at will, reconstituted into an endless combinatorial of media effects.

Just like *Spasm: the CD* where every musical period can be resequenced at will: Gregorian Chant loses its disciplinary quality that signifies the universal panoptic of the Church, and has one last cultural function as a way of flagging the dying energies of heavy metal; human voices dilate into liquid metal rasps; Buffalo grain elevators are transformed into fantastically vivid sound chambers; the abandoned industrial apparatus of rust belt cities is recovered as a site for the brilliant innovations

of *Windows/Strata*. Here, sampler music can be fascinating because it has both a local and cosmopolitan reference. It is grounded in a highly localized materiality of sound objects, but it displaces them against the formal archival background of all western music.

The purpose of all of this is not to escape one's historical contingency or the grim political consequences of the culture of implosion, but the reverse. *Spasm: the CD* actively embraces the digital logic of resequencing history as the only possible basis today for cultural resistance. That is the real political breakthrough of the composer, Steve Gibson. If he rubs pop music icons against the iconography of Western music, that is only to make the point emphatically that ours is a processed world, a sampler culture, where all cultural experience has actually been massaged by technology, rescoped into virtual reality, and then fed to us in recombinant cultural bytes. A world of data fibrillation, sound scans, thermographic TV, high-fashion computer wear, and cellular time.

Refusing to theorize what he has not directly experienced, Gibson rejects the privileged (modernist) role of the music composer standing outside the object of his/her composition, opting instead for the more critical, daring role of an android processor. Not like *Data* in *Star Trek* (although similar in some ways), the android composer is something more interesting. Gibson is a voyager in the dark outer space of digital sound, a computer music hacker who straps on his Akai S-1000 digital sampler and then zooms off into the liquid galaxy of cybernoise. Like a *Star Trek* cadet, Gibson has been to the Academy, in fact to *two* Academies. Deeply conversant with the formal compositional strategies of Western music, Gibson has also been infected with the noise of bodies in ruins in hyper-reality, from Severed Head's *City Slab Horror* and Ministry's *Land of Rape and Honey* to the hard-edged rap of the Jungle Brothers. In his

music, Queen Latifah meets Mozart, and the result is a spectacular soundscape for virtual reality.

With this difference. While traditional composition in Western music always privileged one monolithic structure, which was then successively varied and layered to produce an aesthetic totality, *Spasm: the CD* substitutes ambiguity for narrative closure, and the principles of heteroglossia and radical juxtaposition of unlike elements for the nostalgia of totality. Much like the massive combination of parallel processors to produce the tetra speed necessary for thinking machines, Gibson's android music projects the principle of parallel processing directly into digital sound. Thus, for example, in *Nostalgia for the Future* and *Windows/Strata* three ambiguous structures of music, not necessarily related, are instantly recombined into a dynamic sound field that exhibits all the provisionality and radical ambiguity of the famous "uncertainty principle" in quantum physics. Gibson's music actually creates an uncertainty field, with its own pop algorithmic structures moving at warp velocity and with its own ethical imperative to either "dimension-jump" into the floating world of digital reality or be disappeared as part of the dark missing matter of the virtual world.

Spasm: the CD is "thinking music" that has its own critical intelligence, (machine) sex, (algorithmic) codes, and (cybernetic) memories. It functions as an autonomous, self-replicating organism. In fact, could it be that *Spasm: the CD* has a broader evolutionary significance: actually marking that point where we finally abandoned the land of spatialized images, and descended into the sea of algorithmic data with liquid bodies: digitally enhanced ears, back-lit skin, virtual dildonics, body patches for improved listening, and recombinant intelligence? That moment when we discovered in that matrix of sound waves a more ancient memory. For is not Gibson's recombinant history of Western music the *sound* made by those early twen-

tieth-century discoveries in particle physics and relativity theory, the projection of the *minds* of Einstein, Heisenberg, and Bohr, their fateful explorations of liquid time, curving space, uncertainty fields and relativity theorems, into densely configured and fully ambivalent android music tracks? Is the real secret of *Spasm: the CD* its revelation that the fundamental discoveries of quantum physics have now fused with popular culture, hardwired into the iconography of Madonna Mutant, and Death-Head Gregorian Chant? And if this is the case, then might not the sounds of *Spasm* be a sorcerer's call, teasing out the hidden algorithmic codes of virtual reality for telematically enhanced ears? Consequently, *Spasm: the CD* as a model for intelligent music, a kind of germ warfare for the ears. It signals an uncertainty field where intelligence is (scientifically) uplinked into the android world of particle physics and recombinant genetics, especially when we are seduced by the *foreground* (the trompe l'oeil sounds of the sampler media archive) and forget the *background* (*Spasm: the CD* as already an android invasion of the digitally constituted body).

69

6

SPASM: THE SOUND OF VIRTUAL REALITY II

Steve Gibson

Screen I — Ear Cloning

Spasm 1 — The Recombinant Body

The Recombinant Body is about speed and the creation of a new technobody rhythm. The goal here was not only to speed things up as far as local tempo was concerned, but also to accelerate the formal process into hyper-drive. Taking our cue from the most prominent sample of the work — "just take that memory and put it aside for a moment" — co-conspirator Mark Bell and I decided that our method of dislocation needed to be so rapid and yet so controlled that even John Zorn's *Naked City* band couldn't match it. It was clear to us: the only possible media that could achieve this accelerated process was the computer sequencer.

We therefore have five different tempos which appear in the compressed space of 23 measures:

Mid Tempo Funk (♩ = *102.9*)

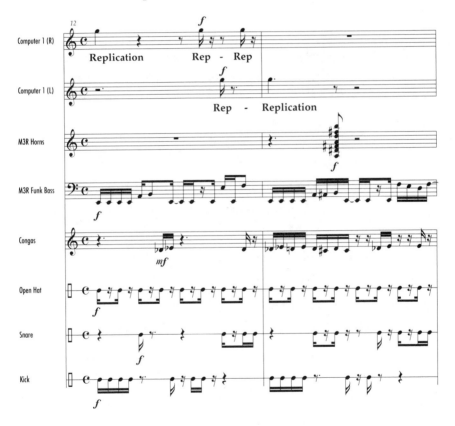

Steve Gibson and Mark Bell, *SPASM*, 1
The Recombinant Body. Measures 12-13.

Mm. 01-06 = 311.3 bpm (*beats per minute*)

Mm. 06-12 = 267.9 bpm

Mm. 12-15 = 102.9 bpm

Mm. 15-16 = 112.7 bpm

Mm. 16-23 = 126.9 bpm

Beyond this, we have the dizzying array of materials which pass us by in a disorienting but seductive montage:

Mm. 01-06 = Crash Sampler Intro — Metro door closing + "just take that memory"

Mm. 06-12 = Industrial Speed Metal — Machine hum sample

Mm. 12-14 = Mid Tempo Funk — "replication"

Mm. 14-16 = Sampler break — "lucky, lucky me" + sentimental strings from *Cinema Paradiso*

Mm. 15-16 = Whitey Hip-Hop — Stone Roses drum loop

Mm. 16-19 = Industrial Lounge Music — "j-j-just take that memory"

Mm. 19-20 = Sampler Interjection — "resume program"

Mm. 20-23 = Industrial Lounge Music — "j-j-just take that memory"

Mm. 22-23 = Sampler Extro — "no discrepancies noted"

The challenge here for the listener is to discard that old human body rhythm, replace it with a new and faster technobody rhythm, crash dance to the accelerated tempo of the dromocratic beat, and chant along with Deanna Troy: "just take that memory and put it aside for a moment."

SpliceCulture — Johnny Mnemonic

Mnemonic Form

Johnny Mnemonic is both a musical expansion of William Gibson's proto-cyberpunk story of the same name, and a vampiric exposition of the musical contents of *Spasm* in embryonic form. Taking Gibson's concept of the idiot savant with a perfect mnemonic memory as a metaphor for the fundamental aesthetic nature of sampled music, I created a parasitic sample sequence (an endless *mise-en-abyme*) which mnemonically spits out quotations and references from each Screen of *Spasm*. With each quoted object generally stated in a single manner throughout, the allusions appear as both vampiric pre-revelations of the already parasitic content of *Spasm* as a whole, and as automatically regurgitated data without a sense of reflection, linear development, or a set program. A narrative of surreal connec-

tions is tenuously established as the prevailing pattern for the ensuing material of *Spasm*, but we are as yet unaware of the necessary links in the chain.

Therefore in *Johnny Mnemonic* the vocal sample from *Windows/Strata* (Vocal G1) materializes only in its most deconstructed form (i.e. very high and very low) without any attempt to reconstruct (and therefore develop) the object, as eventually occurs in the latter piece. Similarly, Arthur Kroker's line "Spasm is speeding down the throats of all the android processors" also appears here almost solely as a deconstructed object, with separate words from this phrase manifesting themselves in an varied, but seemingly random re-iteration of textual data.

At the same time, the drum/vocal loop (Sevocal+beat) from *Nostalgia for the Future* emerges in its most elementary form as a simple two bar loop which never changes and never develops. A metaphoric mnemonic loop is created — perfect replication, perfect similitude: the Romulan commander from *Spasm 1* continually reappears, encouraging the piece to "resume program," and generally the music replies on cue as if responding to a recognized icon (much like the mnemonist who will use code words to trigger a data flow); the Gregorian text from *Seduction-Miserere* appears in the deep auditory background insinuating a different aesthetic world in nascent form; and even Michael Jackson rears his tired, world-weary form to assure us, before he even starts, that he "ain't tired of this stuff." In summation, a world of apparently unrelated icons is set in place, with the few subtle hints as to the possibilities for development cloaked in an "endless combinatorial of cynical signs."

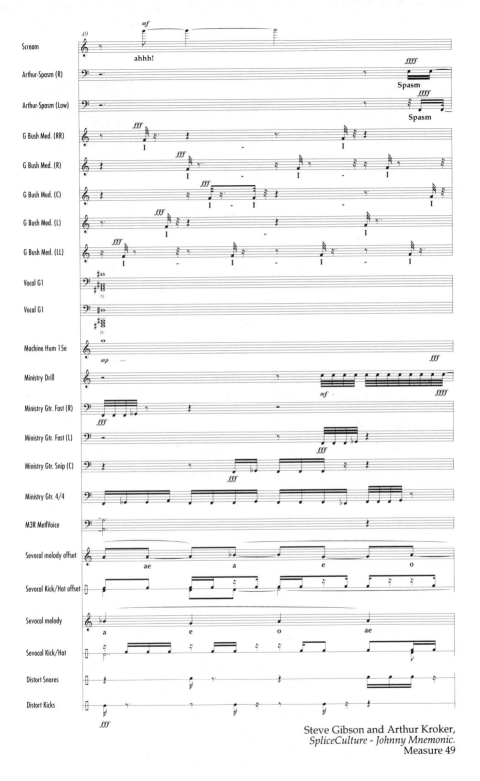

Steve Gibson and Arthur Kroker,
SpliceCulture - Johnny Mnemonic.
Measure 49

The Aesthetics of Cyberpunk

On a more basic level *Johnny Mnemonic* is also an homage to the cyberpunk movement in literature and in popular music. It is, if you will, the recombinant sounds of hyper-cyberpunk, going beyond the already distorted realm of the genre, to a new re-configuration of a re-configuration (again an endless *mise-en-abyme*). As such *Johnny Mnemonic* takes some of the clichés of the genre and pushes them beyond their inherent limits.

Distort Kicks and Distort Snares — The drum sounds used in *Johnny Mnemonic* as a backbeat are not just ordinary drum machine sounds — instead they are over-peak sampled kicks and snares which purposely outdo the simu-distortion endemic to the cyberpunk style by gleefully riding entirely in the red zone: a further distortion of a distortion.

George Bush/G Bush Distort/G Bush Med./G Bush Long — The use of these George Bush samples also acknowledges the influence of cyberpunk, where sampled inflammatory political statements are the norm. Generally the use of such found objects in generic industrial club music is on the simplest and most naive level, and here this is also potentially the case. Cryptically, how-

ever, George is perhaps the only sample in *Johnny Mnemonic* to undergo any substantial transformation throughout the course of the work; and, oddly enough, George never appears in *Spasm* again, except for one, almost inaudible moment at the end of the CD.

Ministry Gtr. Snip/Ministry Gtr. Fast/Ministry Drill/Machine Hum/Neubauten Scrape/Smash Window/Etc. — Another cyberpunk influence is shown in the favoring of "hard" samples — distorted electric guitars, industrial machinery, drills, scraping metal sounds, screams — over softer, more palatable sonic resources. The distinction here is that these "hard" sounds are consistently blended with more subtle elements: Gregorian chant, original vocal samples, bell sounds, etc. Proceeding even further these "hard" samples are manipulated in the latter part of the piece so that they reverse into softer, more delicate sounding objects: the drill becomes an almost beautiful, vocalizing instrument; the machine hum mutates into a seductive drone; and the breaking window re-awakens as a fragile point of articulation.

Why Splice Culture?

Johnny Mnemonic is the opening statement to the general thesis of *Spasm* as a whole. From the outset our supposition has been that the procedures employed by digital samplers and their "android processors" (i.e. computer music composers) illustrate a broad cultural shift which extends far beyond a simple change in the fashion whims of popular music. We have continually proceeded from the belief that the aesthetic and technical procedures of sampler music are perfect simulacra for the multifarious programs of late capitalism; from the cut-and-splice marketing techniques of American multi-nationals to the nostalgia fetish constantly evoked in popular culture and fashion. Therefore, we see *SpliceCulture* as both a simulation of the designer world of recombinant genes, mnemonic memory circuits, and smart bombs, and as a vehicle for articulating a critical interaction with and against those same socio-techno trends; in short our tack is simultaneously that of a parasite and a fortune-teller.

Seduction-Miserere

Malleable Form

Seduction-Miserere is a direct musical reflection on my reading of both Susan McClary's *Feminine Endings* and Jean Baudrillard's *Seduction*. Taking a cue from McClary's critique of masculine closure I created a new "floating" formal program for *Seduction-Miserere*, discarding the formal inevitability introduced in *Nostalgia for the Future* and *Windows/Strata*, and replacing it with a less linear, more open architectural backbone. *Seduction-Miserere* therefore lures the listener into a musical space which asserts no endings and no closure, contrarily insinuating a sensuous and fleeting technoscape: an anti-rational world which eschews the formal logic of late modernism in favour of the "weak" structural illogic of postmodernism. Thus *malleable form,* a seductive and slippery structure, a structure which plays with climax and closure, while ultimately refusing both.

Malleable Icons

As a corollary to malleable form, *Seduction-Miserere* takes a series of *malleable icons* (see *Nostalgia for the Future*) as the basic contents with which to build the whole. Borrowing an idea from Baudrillard (via Barthes), the icons chosen are apparently conventional binary opposites which, after rigorous manipulation, reveal themselves to be immanently reversible in both content and philosophy. Thus, there are three *Miserere* settings which

supply the vocal samples for the piece: Arvo Pärt's very recent work; Allegri's highly popular *stile antico* realization from the seventeenth century; and Michael Nyman's score which appeared in Peter Greenaway's extraordinary film *The Cook, The Thief, His Wife, And Her Lover*. The supposed foils are three drum machine loops taken from the world of nouveau post-punk pop culture: one each from Enigma, Ministry, and Michael Jackson.

As the piece progresses, the interaction between these two seemingly irreconcilable worlds increases to the point where all of the sample sources occupy a substantial space in the foreground (Mm. 93 ff.): each item slides in comfortably with its opposite; and, ultimately, all of the objects yield to the general seductiveness of the backing drum loops. Throughout the piece the body is re-invoked in a genre where it has supposedly been absent for centuries: the rarified world of polyphonic choral church music. The seductiveness of the Allegri *Miserere*, for instance, is emphatically revealed by a layering of the original as a sort of group canon, so that an increasing wash of the source sample builds into a free tonal micropolyphony with several articulations of the original colliding in a dense web of decidedly "non-anitico" vocal polyphony. Similarly, several different "snapshots" from the Arvo Pärt's vocal articulation of the text *Libera me* ("free me") are combined together and layered on top of each other with no temporal displacement. The result is a complete blurring of the textual and musical materials into a phased polyphony of similar objects — again a micropolyphony of sorts, this time achieved by a single (rather than multiple) trigger(s).

The combination of these objects with the drum samples proceeds freely, with bare hints at formal articulation and linear development. Instead of "progressing" in the conventional manner of Western art music, the work proceeds in a kind of formal time travel — returning to samples insinuated earlier in the piece, casually discarding ideas brought up the at the start

of the work, and finally leaving room for speculation on different possibilities for the samples in question. The result is a structure that seduces rather than asserts, a sound world that moves with free will rather than deterministically, a self-critical arrow shot at the formal traditions which I, as a male Western art composer, have inherited and exploited — ultimately a relief from the expectations of the formal avant-garde.

Special note on the vocal samples for *Seduction-Miserere*

The digital manipulation exploited in *Seduction-Miserere* goes beyond much of the more conventional processing employed in the rest of *Spasm*. This is particularly evident in the Allegri and Arvo Pärt samples. For instance, the samples labeled Allegri Skip 3-5 in the score for *Spasm* were generated by taking a small excerpt from the original piece (in this case the word *confirma*) and fastidiously re-constructing from this a new "skip-sample." These new sounds were created by experimenting with the digital rewind on the source compact disc player. Essentially I improvised several different rewind patterns until I found a few that produced the most exciting results. Ultimately I was left with five "skip-samples" which represented successively increasing revelations of the source text (Skip 5 exposes only the end of the text, while Skip 1 reveals the entire word). Of these, the three last samples were employed in the piece.

The Arvo Pärt samples on the other hand, display an intense post-recording manipulation executed on the Casio FZ-1 sampler. I took seventy-five digital "snapshots" (see above) from the source piece, once more representing successive revelations

of the sampled text (in this case the phrase *Libera me*). Of these seventy-five "snapshots" I chose eighteen samples with which to work. Six samples were assigned to each of the three MIDI channels used, and the three samples representing the most proximate articulations were placed on the same original trigger key and given a two-octave range. This essentially resulted in a keyboard setup where successive blurred samples could be sounded by proceeding from the lowest octave on the first MIDI channel to the highest octave on the third MIDI channel: the bottom two octaves on channel one triggered three articulations from the attack of the original, and the top two octaves on channel three triggered three articulations from the very end of the original.

Spasm 2 — The Partitioned Body

The Partitioned Body is based on a proposition that Arthur Kroker brought to my attention in the summer of 1991: could I create a sound partition using a minimum (1-3) of triggers to activate several cross-faded samples? After a look into the depths of my Casio sampler, I determined that this proposal was quite feasible, and could be effortlessly realized by using an unorthodox keyboard arrangement in tandem with carefully edited DCA settings on each of the samples.

I began the experiment by organizing the sampler keyboard so that all of the samples could be triggered on three keys. I then took two long samples from Radio Prague (which I pasted together), one sample loop from Cabaret Voltaire's *Code* CD, and one short sample from an anonymous radio advertisement. The Radio Prague and Cabaret Voltaire samples were placed on one

key (C4) of the keyboard, with the VCA attack of the former set on 99, the latter on 10. The short radio ad was placed on two keys (B3 and C#4), panned left and right, with a VCA attack of 99. The piece was generated by a simple depression of C4, which caused an immediate trigger of the Radio Prague samples, followed by a slow fade-in of the Cabaret Voltaire until the two samples were at equal amplitude. As soon as this was attained the short radio ad was triggered on the B3 and C#4 with a slight velocity fade-in. After a brief moment the Radio Prague samples finished, leaving the remaining two samples in the forefront. These two samples were then concluded in perfect synch by exactly timing the loop repeat set ups of each sample.

Screen II — Sacrificial Ears

All of the pieces in *Screen 2* of *Spasm* are reflections on popular culture icons and issues, from Madonna's philosophical outlook ("everyone must stand alone") to power and appropriation in digital culture ("*I've* got the power"). Both of the larger pieces take a popular genre (*Madonna Mutant*-industrial disco; *Will to Power*-hip-hop) and send it for a new twist.

In direct opposition to most of the material contained on *Spasm*, the works on *Screen 2* of *Spasm* eschew formal reflection on the nature of sampling and sampling technology. Rather than searching for a new idiomatic structural language for digital samplers, they readily accept a popular culture view of found objects: sampling as simple re-contextualization. These pieces state their samples as pure imitations of iconic models — the critical reflection here comes about not via an elaborate distortion of these objects, but by a re-oriented context.

Spasm 3 — The Accelerated Body/The Displaced Ear

The Accelerated Body uses three samples from the world of hyper-drive popular culture as its basic sound objects: Ministry, John Zorn, and Severed Heads. The Ministry sample consists of an intensely fast industrial metal beat (tempo=176.1 bpm) from the *Land of Rape and Honey* CD, which has been cut and looped to produce a steady 4/4 beat. The Zorn sample consists of the final two measures of *Igneous Ejaculation* from the *Naked City* CD, and emphasizes the distorted voice of singer Yamatsuka Eye. The Zorn clocks in at 117 bpm and is therefore roughly 2/3 of the tempo of the Ministry sample, allowing for an interesting blend of the two objects. The Severed Heads sample is a distorted laugh taken from *Spasm* (!) on their *City Slab Horror* CD. This sample runs at approximately the same tempo as the Zorn and is cut to produce a roughly coherent 4/4 pattern.

A final two samples are added to the piece as foils to the speed samples. These objects are two of the sound sources also used in my piece *Windows/Strata*: the first is a brief metal sample played at pitch; and the second is a vocal sample displaced down two octaves and tritone, which serves as an inhuman drone.

In *The Accelerated Body* the samples are developed in a very brief period of time, with each sample illustrating a particular process as the piece unfolds. The Ministry beat is replicated as four samples, triggered at first as two stereo objects in perfect synch. The right and center panned attacks of the sampled beat are soon displaced, at first only by a small amount of time (a 64th note), and later by a much larger increment (3 beats and a dotted

8th note). At first the effect is one of slight phasing, but later as the displacement begins to produce real syncopation, the illusion of a halved internal rhythm is perfectly simulated. Curiously, at the instant when the samples reach an audible rhythmic saturation point, the piece suddenly drops into a much slower tempo: as if to discount or undermine the sudden simulated speed acceleration the Ministry sample is now triggered down a fifth (producing a tempo of 117 bpm), and later down an octave and a fifth (58.5 bpm).

The Zorn sample follows a related process of development throughout the piece — only in this case displacement is not the preferred procedure, but rather addition. Simply stated, the Zorn sample becomes more apparent during the course of the work. At first appearing only sporadically, it continues to insinuate itself until, by constant rhythmic accretion, it also contributes to the saturation point achieved before the ultimate collapse. For a brief moment it appears as a privileged object in the foreground, and reveals its own special rhythmic character (before this its own internal rhythm was completely submerged by the pervasive power of the Ministry beat). Its dominance, however, is short-lived and the sample never appears in recognizable form again.

The cynical laugh sample follows a much simpler procedure, acting as a continual reminder of the opening. The laugh returns briefly in the middle of the piece as a small interruption of the constant rhythmic pulse of the two main samples. Its reappearance at the end — first as an object displaced down in pitch and thus relating to the slowing of the Ministry sample, and later as a phase-shifted object similarly mirroring the general development of the Ministry sample — echoes the thematic of the entire work, and at the same time returns the piece to its starting point: the first and last laugh.

The samples culled from my own piece *Windows/Strata* also serve comparatively simple functions. They act as the means of articulating the point of complete inertia in the exact middle point of the piece, an ironic reminder of the illusion of speed amidst the simulated frenzy of an overdriven sample sequence.

Madonna Mutant

As samplers are used in *Screen 2* primarily as easy simulation machines, in *Madonna Mutant* Madonna herself appears as an iconic image of American vampiric culture, seductively repeating her fateful philosophical credo: "everyone must stand alone." Her endless chorus is forcibly merged with an exaggerated industrial dance beat synched in a perfect tempo lock with the philosopher-queen (122.3 bpm). So also our pomo chanteuse finds herself in a re-oriented harmonic world with the addition of a sinewy new bass line which pulls against Ms. Ciccone's vocal line in a slippery series of M9ths, M7ths, and octave doublings.

Throughout the piece my theory cohorts, Arthur and Marilouise, persistently strap onto the technoscape with laconic commentaries on Madonna's image construct: "she's a perfect Madonna...the real Madonna myth," or "the production of neon libidos in the age of sacrificial sex." As the music moves forward the texture thickens portentously, seductive Madonna slowly becomes more fluid (a simple detuning of her left side sample by 5 cents causes her to go out of phase with herself), nasty Madonna rears her ugly head ("what do you mean it's not in the computer"), and in the end the piece weighs down on itself as the icy strings join in as an eerie accompaniment to

SERIAL LOVER

Madonna's real truth or dare: is Madonna a human being or a
technomutant? Via *Madonna Mutant* — in the age of the perfect
imitation-simulation machines — she is both, whether she likes
it or not.

Will to Power

Will to Power asks the following questions: how does ap-
propriation in digital culture model the gender relationships,
power structures, and racial politics of the late capitalist era?
what is the distinction between subliminal suggestion and
subtle inference? what is real and what is virtual? can white
boys with too much technology really get funky only by
stealing black culture?

As a background to these issues *Will to Power* shamelessly
exploits the essential dance music format of the past ten years:
the extended disco re-mix. The droning intro with appropri-
ately foreboding samples; the long "splice-and-dice" preview
of coming attractions; the cascading verse and chorus; the
obligatory rap; the chaotic trail out; the final post-coital release
— within this time-worn format (ten years is a long period in
pop music history) subtle and not-so-subtle layers of textual
and musical inference pile up in yet another "spiralling combi-
natorial of cynical signs."

Early in *Will to Power* the sampled black singer eagerly as-
serts her liberatory chorus, "I've got the power." As the piece
progresses her voice is slowly dominated by a chorus of
Nietzsche's monsters: "power, money, power, lust;" or "I've got
the power, to reassemble your body." The samples begin to
merge with the sung text; the "real" text begins to modify the
virtual text, and eventually a curious confusion between the
sampled and the sung is established. The white boy vocalist
growls out his cynical corporate post-structuralism: he contra-
dicts himself continually; he is reinforced by the samples; he is
attacked by the samples; he retreats; he attacks again full-force;
and in the end he is forcefully reprimanded by his alter ego who
delivers a final devastating meditation on the will to power at
the fin-de-millennium. Ultimately the darkness hidden just
below the surface belies the simple get-up-and-dance attitude
of the audio foreground, and the piece goes into melt-down
with the gender-warped voice of Kim Sawchuck urging us —
both audibly and subliminally — to "reassemble our bodies as
machine." We cannot help but obey her.

Spasm 4 — The Aliasing Body: Elvis' Lisp

All of the sounds used in *Spasm 4* were culled from the Elvis
CD collection entitled *Number One Hits*. While doing a rather
arbitrary sample search through this disc, Mark Bell and I made
a somewhat surprising discovery: Elvis possessed a clearly
audible lisp on his rendition of the line "I've found a new place
to dwell" from *Heartbreak Hotel.* Sensing some unusual pos-
sibilities, I focused my attention on the offending word, "place."
After completing some elaborate time-stretching, octave dis-
placements and reverse articulations I found a whole new Elvis,

a clear representation of his "dark side."

This dark, eccentric Elvis eventually provided me with the architecture of this brief piece, essentially based on a reassembly of the word "place" over a drone generated from that very same word. As a matter of course "Dark Elvis" was also combined with some very iconic samples from the same disc, and sequenced in a manner in keeping with the off-beat nature of my discovery. The result is a quirky, eccentric vision of the King just before he went for that secret, unacknowledged speech therapy.

Screen III — Architectural Ears

Spasm 5 — The Phased Body

The Phased Body follows a path similar to that established in *The Recombinant Body* — in this case, however, the dislocating splices do not proceed as rapidly, the phrase lengths are more regular in length, and there are several restatements of material throughout the piece. This more controlled environment is evident in the tempo structure:

Mm. 01-08 = 94.0 bpm
Mm. 08-16 = 121.6 bpm
Mm. 16-17 = 94.0 bpm

Mm. 17-25 = 140.1 bpm

Mm. 25-39 = 94.0 bpm

The returns to a tempo of 94 bpm represent solid restatements of material, but with a twist — here the restatements are formally "phased" (i.e. overlapped) with material from the other sections, or from other pieces. The outline of the material is as follows:

Mm. 01-02 = Crash Sampler Intro — phased window smash + metal pickup + toms simumetal pickup

Mm. 02-08 = Slow Doom Funk — Peter Gabriel beat + "the body itself..."

Mm. 08-16 = Hip-Hop — Jungle Brothers cut voice/looped beat + reversed and looped Severed Heads vocal sample

Mm. 16-17 = Slow Doom — PG beat + forward SH vocal sample

Mm. 17-25 = Fast Spastic Industrial Jazz — w/ auto deconstruct bass pattern + machine hum (from *Spasm 1*)

Mm. 20-25 = Underlying Vocal Drone — phased SH vocal sample faded from a volume of 2-127

Mm. 25-32 = Slow Doom — phased and displaced PG beat + phased SH vocal sample

Mm. 32-39 = Underlying Vocal Drone — phased
SH vocal sample alone

"The body as a conveyor of files" here becomes a metaphor for the digital conveyance and distortion of both the human voice (SH, JBros.) and human body rhythm (PG). Through local and large scale phasing the technobody is established as a mutant form of the real: "the body *itself* becomes a conveyor of [digital] files."

Improved Ears — Nostalgia for the Future

Improved Hearing

Nostalgia for the Future incorporates both the user-intensive programming functions of the Akai S-1000 sampler and the updated controller options for the Performer 3.5 computer sequencer to create a simulation of a new sound cranium — an improved hearing apparatus in which the listener's ears and surrounding skull are directionally activated, and where the body itself moves into a virtual space of seductive artifice and simulation.

Nostalgia for the Future requires headphone listening, as well as a deprivation of the traditionally privileged human sense organ: the ever-present eye. For too long sound has been relegated to the backwater of external stimuli, always yielding dominance to the insatiable need for visual sensation. Yet this need not be the case. Using the new digital technologies presently available and a little imagination, the ear can be opened up

to a new level of sensual and intellectual pleasure. With a thorough exploitation of the imaging capabilities of user-intensive gear such as the Akai S-1000 digital sampler, the composer can explore the possibilities for a physical activation of a listener's head space. A new virtual head can be created, but unlike cyberspace, the body need not be discarded and left aside. Rather, it can be strapped on and brought along for the ride.

Malleable Icons

Nostalgia for the Future takes several sound objects from sources which appear to be mutually exclusive: Severed Heads, Gregorian Chant (via Enigma), Einstürzende Neubauten, Renaissance polyphony (via Severed Heads), as well as two vocal samples created at the Buffalo River Grain Elevators. The apparent irreconcilable contradictions between these sources is rendered illusory under the homogenizing effects of a digital sampler and its trusty automaton. Each object is forced into a reconciliation with apparent polar opposites: the Severed Heads play a quantized pattern in exact synch with Gregorian voices chanting *In nomine;* Einstürzende Neubauten play a layered metal rhythm in a deep auditory recess (a position the noisy Germans are not accustomed to) while the Renaissance and Gregorian voices intone over a heavily manipulated Severed Heads bass; eerie vocal samples (truncated to start at peak amplitude and thus simulating a metallic attack) copy, develop, and dialogue with the rhythmic patterns of both the Neubauten metal and the Severed Heads electro-bass; finally, a Gregorian melody is cut and looped so it fits cosily in synch with a Severed Heads drum machine pattern.

The lesson is clear: *the sound object is infinitely malleable in the*

face of digital samplers and computers.

How is this fluidity possible? The answer is simple: by utilizing the rudimentary rhythmic editing functions of a digital sampler in tandem with the strict rhythmic accuracy of a computer sequencer, any number of objects are infinitely malleable. A Neubauten metal pattern can be forced into the same tempo as a Gregorian chant by simple detuning. A Gregorian melody can be truncated and looped in such a way as it slides easily into place under a techno-beat from the Severed Heads. The same Severed Heads beat can be cut off suddenly and sequenced as a new pattern of attacks, which can then be doubled with a similarly truncated Gregorian sample. The possibilities are limited only by the imagination of the composer — the great leveller, tempo, equalizes all.

This is not to imply that every sound object will immediately reveal its contextual malleability with a simple rhythmic lock to another object. There is certainly more involved here. However the fluidity displayed in *Nostalgia for the Future* shows that the seed of an object's malleability lies in its rhythmic character. Force an object into a new tempo or rhythmic arrangement through digital manipulation and one can completely alter its context. With further distortion via unusual truncation (voice becoming metal) or extensive imaging (placing sounds directionally), the object becomes even more susceptible to a fluid re-orientation. With some careful work, astonishing correspondences between diverse sources can be clearly revealed.

Nostalgia for Distortion

The formal program of *Nostalgia for the Future* proceeds from an ongoing attempt to find an idiomatic structure for sampler music. The architectural answer lies in three discrete over-all strategies: the *ex nihilo* move from nothingness at the opening to nothingness at the end; the gradual prosthetic restructuring of human voices from both metal-like attacks and inhuman wailing to "natural voices" at pitch (fantastically appearing only at the very end); and the slow yielding of dominance established between two rhythmic patterns. Underlying these concerns is one idea: the principle of distortion. A game is played out in which each object is distorted to a lesser or greater degree, each according to different procedures and each with a different result:

Enigma Gregorian Chant — a sample of a sample (*mise en abyme*), in this case a simple Gregorian melody taken from Enigma's *MCMXC a.D.* CD. This sample appears in various guises through-out the piece — three general states are observable however.

The first is demonstrated at the opening where the Gregorian melody is stated as a menacing palindromic canon {palindromic=same backwards and forwards; canon=same melody overlapped at different times} at a pitch level displaced 2-3

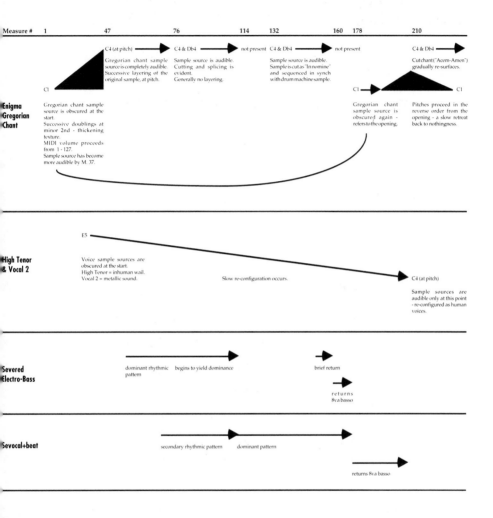

Measure #	1	47	76	114	132	160	178	210

Enigma Gregorian Chant

C4 (at pitch) ▸ C4 & Db4 ▸ not present C4 & Db4 ▸ not present C4 & Db4 ▸

Gregorian chant sample source is completely audible. Successive layering of the original sample, at pitch.

Sample source is audible. Cutting and splicing is evident. Generally no layering.

Sample source is audible. Sample is cut as "In nomine" and sequenced in synch with drum machine sample.

Cut chant ("Acem-Amen") gradually re-surfaces.

C1

C1 ▸ C1

Gregorian chant sample source is obscured at the start.
Successive doublings at minor 2nd - thickening texture.
MIDI volume proceeds from 1 - 127.
Sample source has become more audible by M. 37.

Gregorian chant sample source is obscured again - refers to the opening.

Pitches proceed in the reverse order from the opening - a slow retreat back to nothingness.

High Tenor & Vocal 2

E5 ▸

Voice sample sources are obscured at the start.
High Tenor = inhuman wail.
Vocal 2 = metallic sound.

Slow re-configuration occurs.

C4 (at pitch)

Sample sources are audible only at this point - re-configured as human voices.

Severed Electro-Bass

dominant rhythmic begins to yield dominance
pattern

brief return

returns
8va basso

Sevocal+beat

secondary rhythmic pattern dominant pattern

returns 8va basso

Steve Gibson, *Nostalgia for the Future.*
Overall form.

octaves down from the original. The result of this displacement is a complete submerging and utter reversal of the original identity of the chant. Instead of conveying a sense of purity and beauty it now appears as an oppressive and ominous drone. The original chant (slightly cut) does appear in the deep audio background for two brief moments; however here it sounds decadent and corrupt because of a doubling at the minor second.

This first state of the chant disappears after M. 47 and does not re-appear until near the end of the piece (Mm. 210 ff.). At this point the palindromic canon ominously re-surfaces along with two Gregorian voices endlessly intoning "Amen" out of phase--the resulting retreat to the nothingness of the opening is a perfect semiotic code for the endless *mise en abyme* engendered by samplers.

The second state of the Gregorian chant occurs part way into the work, appearing quite regularly from Mm. 63 ff. This state more faithfully recreates the sound and symbology of the original chant, however the sampler is set up in such a way as to allow the chant melody to be triggered in its

entirety by the simple touch of any key. The resulting wave caused by simple 16th note attacks on the same pitch alters the quality of the chant melody again, although in this state there is a sense of increased splendor rather than the increased decadence of the first transformed state.

The final state of the chant occurs in the central part of the piece (Mm. 132 ff) and represents a simulation of a simulation, a demonstration of the malleability of objects mentioned earlier. The chant is cut so only the words *In nomine* are sounded. The sample is then sequenced in exact quantized synch with a similarly truncated Severed Heads drum sample; the voice of the Middle Ages is thus forced to play a weird but compelling unison melody with the voice of technology.

<u>High Tenor Duet</u> — a voice sample from the Buffalo River Grain Elevators, a simple but somewhat slippery melody sung by film-maker Seth Tamrowski and myself.

This sample undergoes a comparatively simple procedure of reverse distortion. In this case the

technique is one of reconstruction: the sample appears at the outset of the work as a high inhuman wail (displaced up two octaves from the original sample) and slowly proceeds down throughout the work until near the end (just before the final re-appearance of the Gregorian canon) it appears almost out of nowhere at pitch, fantastically reconstructed as a human voice.

Vocal 2 — another voice sample from the Buffalo River Grain Elevators, this time a simple consonant harmony sung by Paula Hanlon, Mark Bell, Vincent Hammer, and myself.

This sample is truncated in a very unorthodox manner, with the start point established part way into the sample so that the attack occurs in the middle of the vocal articulation, at the point of highest amplitude. The resulting sound has a metallic quality (as mentioned earlier), which is especially evident when the sample is displaced up in pitch. Vocal 2 undergoes the same procedure as the High Tenor Duet, proceeding down from a metal sound and finally appearing, at the same fantastic moment, re-configured as a human voice.

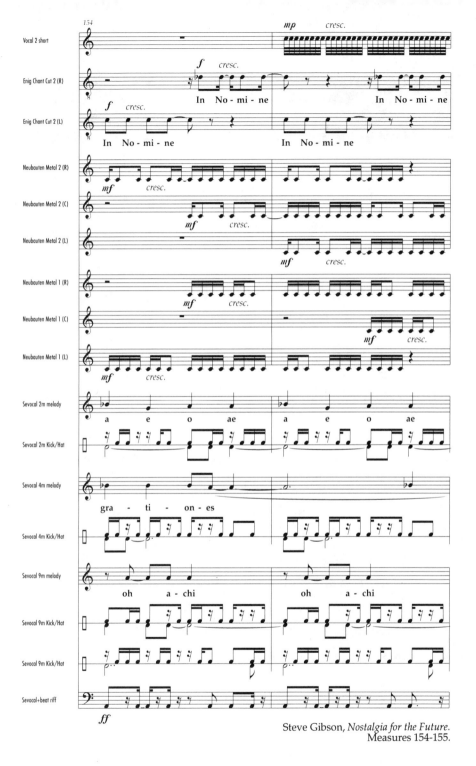

Steve Gibson, *Nostalgia for the Future.*
Measures 154-155.

Vocal 2 also has an auxiliary function related to the malleability of objects mentioned at the outset: it appears throughout the piece primarily as a short metallic sound playing a consistent 16th note pattern in dialogue with the Neubauten metal sample and the Severed Electro-Bass.

Severed Electro-Bass — a mix of 9 different samples, all from the same source piece, with each time-stretched slightly differently.

This sample always appears as a highly distorted object throughout (the only sound to do so) and functions as the dominant bass and rhythmic pattern through much of the first half, slowly yielding up this position during the course of the work. Towards the end, the sample returns briefly, first as a reference to the earlier section of the piece, and later as a hyper-distorted object (transposed down one octave).

<u>Sevocal+beat</u> — a sample from Severed Heads CD *Cuisine/Piscatorial,* in this case the object is an original drum pattern of the Heads, combined with a vocal duet which has the quality of a late Renaissance/early Baroque madrigal. In other words, this sample is both a sample of an original object and a sample of a sample.

Sevocal+beat appears almost consistently as a fairly distinct object, as a foil to the previous sample — it is the basic source which takes dominance in the second half of the work, usurping the original role of the Electro-Bass sample. The sample does undergo some development in the latter part of the work, becoming increasingly layered as the piece progresses, until there are more than six phased or displaced attacks of this sound occurring at the same time (Mm. 155 ff).

<u>Einstürzende Neubauten metal</u> — a sample from the piece *Yu-Gung* which, when originally sampled, seemed almost like a backwards spinning top. However, when reversed, the "spinning top" was revealed to be a metallic rhythm, suggesting that musicians had reversed their own sample in

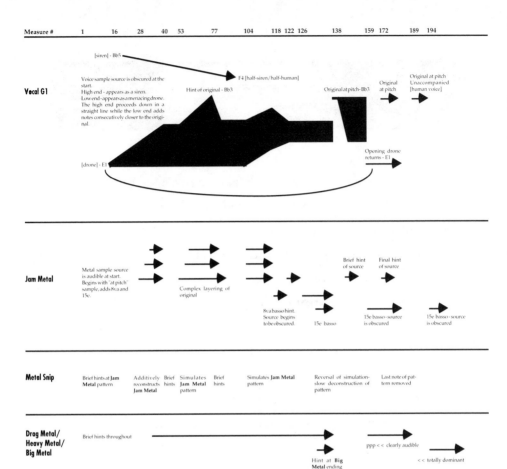

Vocal G1

[siren] - Bb5

Voice sample source is obscured at the start.
High end - appears as a siren.
Low end - appears as a menacing drone.
The high end proceeds down in a straight line while the low end adds notes consecutively closer to the original.

Hint of original - Bb3

F4 [half-siren/half-human]

Original at pitch - Bb3

Original at pitch

Original at pitch Unaccompanied [human voice]

[drone] - E1

Opening drone returns - E1

Jam Metal

Metal sample source is audible at start. Begins with "at pitch" sample, adds 8va and 15e.

Complex layering of original

8va basso hint. Source begins to be obscured.

15e basso

Brief hint of source

Final hint of source

15e basso - source is obscured

15e basso - source is obscured

Metal Snip

Brief hints at **Jam Metal** pattern

Additively reconstructs **Jam Metal**

Brief hints

Simulates **Jam Metal** pattern

Brief hints

Simulates **Jam Metal** pattern

Reversal of simulation- slow deconstruction of pattern

Last note of pattern removed

Drag Metal/ Heavy Metal/ Big Metal

Brief hints throughout

Hint at **Big Metal** ending

ppp < < clearly audible

< < totally dominant

Steve Gibson, *Windows/Strata.*
Ambiguous Structures.

order to create a new backwards attack. In yet another reversal, the sample is used in *Nostalgia for the Future* as a metal object (this is achieved by using the reverse mode of the sampler to create a forward attack of a backward masked sample!).

This Neubauten metal sample was detuned in order to fit into the tempo established by the Electro-Bass and the Sevocal samples. It is the only object to *never* appear in distorted form, and its role in the piece is as a simple reminder of the consistent pulse artificially established in the piece, a consistent articulation of the homogenized tempo and rhythm created between the malleable icons.

Why Nostalgia for the Future?

Because in an ironic way this piece *is* nostalgic for the future; it is nostalgic for a time when pedantic automatons will be able to take any object and mix it with any other, a time when sound waves will be intercepted by anyone, re-configured as new objects, and mixed with other sounds retrieved in the same manner. In its own way *Nostalgia for the Future* articulates the first yearnings of a culture yearning for quick, easy, robotic piracy.

The Pedantic Automaton — Windows/Strata

Windows/Strata can be considered a companion piece to *Nostalgia for the Future*. Like *Nostalgia...*, it seeks to create an idiomatic relationship between the sonic qualities of the employed samples and the outline of a large scale form. In this case, however, the objects that are employed are not the "malleable icons" of the former work, but rather newly created samples culled from improvisatory sessions recorded at the Buffalo River Grain Elevators, a series of cylindrical concrete structures approximately 150 feet in height. Each sound in *Windows/Strata* was created spontaneously using materials found on this site and the voices of the participants. The resulting work reflects both the abstraction and decay evident in the structure of these ruined monuments of the modernist dream.

Ambiguous Structures

What are the structural implications of using digital samplers and sampled materials? how should content dictate form in our age of happy parasitism? *Windows/Strata* answers by acknowledging the two primary functions of digital samplers — simulation and distortion — and invoking these functions themselves as large-scale formal principles: reconstruction and deconstruction. Conventionally, sampled music has limited this type of re-configuration to basic context shifts on the small scale (i.e. the narrow re-contextualization of the hip-hop James Brown sample). In contrast *Windows/Strata* insinuates the pos-

sibility of realizing re-contextualization over the course of an entire piece, with each object treated according to individual and idiomatic procedures. The result: ambiguous structures.

Schenker est Mort

As an aid to the development of ambiguous structures *Windows/Strata* samples an idea from the nineteenth century — multi-function form — and adapts it to the post-Schenkerian situation. The overall form of *Windows* employs the foreground, middleground, and back-ground familiar to Shenkerian analysis. However, instead of unifying the levels (in the old modernist way) by outlining the same processes in each, the layers here are formally exploded, with each strand outlining a contradictory program. This arrangement creates a polysemic, plural formal structure which suitably allows for the development of the different samples according to their special characteristics: for the technological composer a perfect solution to the search for an idiomatic structure in sampled/sequenced music.

Foreground — The foreground structure of *Windows/Strata* is based on a continual dualistic alternation between the primary voice sample (which is slow, quiet and rhythmically free) and the primary metal sample (which is fast, loud, and rhythmically precise). This simple A>B alternation

is continually re-affirmed throughout the piece; however, the established binary opposition is subtly but constantly undermined by the seductive insinuations of secondary samples which exhibit characteristics disparate from those of the primary two samples. A continual affirmation and refusal ensues, with no apparent victor arising until the very end, when an entirely new and powerful sample appears out of nothingness and presents its own final devastating rejection of old, male binary thinking.

Middleground — A more middleground level formal process at work, related to the *Strata* of the title, involves both peeling away sound strata to reveal underlying sound objects, and suddenly altering dynamic levels to create immediate reversals in the relative dominance of the main sound objects. This is achieved by using MIDI controllers to precisely place the swells, spikes, plunges and sweeps which articulate and disrupt the points of formal articulation, often leaving residue from former sections in the far auditory reaches of new sections. The result is a continuous formal cross-fading where boundaries begin to

blur and distinctions between the A>B foreground sections become more uncertain and ambiguous.

Background — On the background level, the dominant procedure involves processes of alternately "hiding" and "revealing" the sources of the primary samples. At the start of the piece the voice sample is shown distantly removed from its original pitch: in the low end it sounds as a indistinct drone and in the upper range it appears as a siren-like sound. Over the course of the piece the sample "comes out of hiding" (reconstruction) as it is presented successively closer to its original pitch. Proceeding down from a siren and up from a machine drone, near the end of the piece the sample magically appears alone, at pitch, re-configured as a human voice.

The metal sample on the other hand is originally presented at pitch, its source and nature clearly revealed. Throughout the work the sample is slowly "hidden" (deconstruction) as it is continually displaced down from its original pitch. At the end, its rhythmic precision has been grotesquely disfigured by a displacement down two octaves,

resulting in a clangorous, arhythmic parody of its original perfection. Thus, nostalgia for distortion, again.

In another background level process, the rhythm of the looped Jam Metal sample is "filled in" over a long period by the short metal sample (Metal Snip 5). MS 5 additively matches the rhythm of the Jam Metal sample, beginning with a single 1/8 note and adding notes one at a time until the pattern is filled in. The effect here is one of a similitude created by slow accretion on the large scale — a perfect mirror of the simulational possibilities of digital samplers.

The Pedantic Automaton

Why *The Pedantic Automaton*? Because here we finally come to realize that the content of a composition can be generated not only by a simultaneous formal deconstruction, reconstruction and stasis, but also by a prosthetic reconstruction of the human voice, an aesthetic deconstruction of human-generated rhythm, and a simulation of humans by machines. The human voice becomes a machine-like drone or a screeching siren, whether it likes it or not. Similarly the pseudo-precise rhythm of a human performer (myself in this case) reveals its limitations when transposed down two octaves, slowed to the point where

inconsistences are microscopically evident. And in the end the human performer is forced to allow the ascendency of a precise quantized simulation of itself. The analysis is inescapable: humans are by default pedantic automatons to superior machines.

Spasm 6 — The Hegemonic Voice: The Sound of the Right

The Sound of the Right — under the sign of viciousness for the fun of it.

The Sound of the Right — here, a recuperation of the original consciousness of *Spasm*, though with no sense of recapitulation (nihilistic nostalgia).

The Sound of the Right — it is vicious, annoying, and endlessly repetitive.

The Sound of the Right — to listen to the sound of the right your media interceptor can provide you with all you ever could require. At this point you must decide: take it or leave it, there is no alternative.

"SPASM is speeding down the throats of all the android processors."

7

CRASH MACHINES

Downtown Phoenix, Arizona is the home of *The Ice House,* a culture lab for the study of the pathological consequences of high-technology. In that lab a possessed artist, David Therrien, like an alchemist of old, has seduced the heretofore inert world of machinery, making it come alive in the petrie dish of performance art, and demonstrating its fatal power. Like a digital genie escaping from the sealed bottle of techno talk, he forced it to announce that technology has finally acquired organicity. Cold metal has come alive and begins to sing songs of cultural electrocution; electricity blasts outwards in a brilliant white light that has all the religious undertones of theosophy; TV is revealed to be another form of germ warfare on an unsuspecting population; and the mediascape moves at the fast shutter-speed of the catastrophe voyeur.

Therrien's world is populated by crash machines: electric inquisition machines, suicide machines, INDEX (Machines for the New Inquisition), comfort machines, 90 Degree Machines,

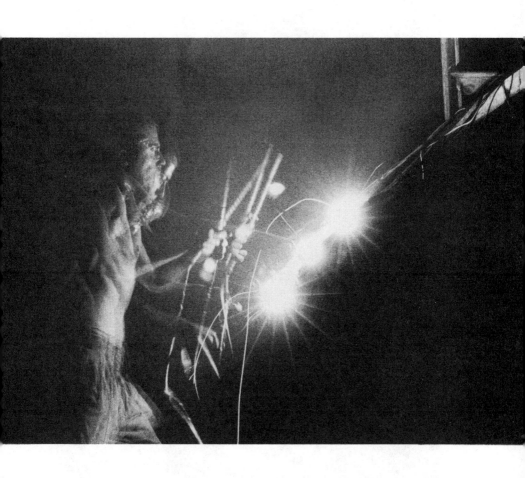

Ritual Mechanics by David Therrien

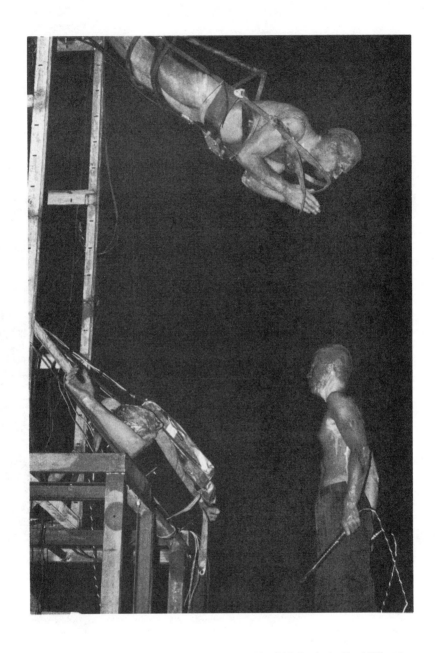

Ritual Mechanics by David Therrien

112

and Fetal Cages. Not machines as much as liquid power fields that configure and reconfigure everything sucked into their energy paths, making of the body-machine interface a galactic uncertainty field.

And not just crash machines, but crash bodies too. Naked bodies trapped between gigantic rubber percussion pads through which shoot 16,000 volts of electricity; squashed bodies shoved into tiny circular steel cages and then suspended forty feet from the ground, all the while surrounded by a power field of high-voltage electricity. Or crash bodies strapped to the top of a gigantic crucifixion machine, the face of which is hidden behind a massive quartz light that without warning blasts alive, becomes blindingly luminescent, like one-thousand aircraft landing lights coming on simultaneously. This pyrotechnics not only for entertainment, but as a brilliant way of demonstrating our fate as passive passengers along for the ride on the violent trajectory of digital technology.

Rituals of Purification

Who would have ever thought that Therrien is a priest of high technology? But that is exactly what he is! He's one of those strange desert prophets who strains the world of hard-edged cyberware through a hybrid form of moral reflection. All of his work is deeply religious in the most profound sense: an ethical insistence that technology respond to the ultimate questions. What are the ethical implications of a media machine that makes us complicit in the purely specular position of the voyeur? What happens to the horizon of human subjectivity when it is reduced to the passive metabolic position of a silent, and admiring, passenger on the high-velocity blast off of digital technology?

And what are the "rituals of purification" by which the secreting body is sanitized for its voyage through the dark mass of virtual reality?

If Therrien can decode with such chilling accuracy the canonical text of cyber-reality, that's because he is a missionary of a different order— an android priest who makes of his body a passing field of quick and violent mutations as it is forced through the energy field of the screen of the simulacrum. This is not simply a talking preacher, but a sacrificial artist with manic energy who can overpower the high-voltage charge of humming electronic grids, make electrical current seem like tedious slow motion when approximated to his own performance demands (to be dipped in and out of a humming grid of 31,000 volts of electricity), and whose notion of audience therapy is to have his body constantly monitored during performances by EKG and brain scans for any signs of approaching terminal functions. And all of this not only for the purpose of scandal, but as a way of ripping away the closed narrative veil of technological discourse, thereby revealing its possibilities for decomposition and recovery.

Techno-Mutants

All of Therrien's work involves a threefold combination: electricity, digital computers, and music: i.e., the pure power grid of virtual reality. This grid exists as a quantum reality where electricity is energy (achieving pure space in quartz lighting), computers (the network), and music (the seduction principle by which crash machines come alive). His is a relational world that is charged by electrons, scanned by cyber networks, and triggered by digital media impulses. The body is always passive

meat trapped in "fetal cages," suicided by its fast transmission through "comfort zones," or slaved to machinal automatons. A liquid world where bodies float in a fluctuating sign-position between predator and parasite, and where machines operate under the doubled psychological sign of cruelty and fascination.

Or is it the opposite? Not so much slaved bodies, but violent bodies that strap on an outer techno-skin (quartz lights, two story steel constructions, inquisition cages, TV sets for comfort eyes) to see how fast technology will go, how far the technosphere can be pushed before it begins to rebel, becoming a passive passenger to this brutal projection of human psychosis. Crash technology, therefore, that perhaps never wanted to move at such speed or to announce its violence so openly, but has been compelled to do so by crash bodies acting under the double performative principle of predator/parasite.

Let's be honest. Therrien's world of crash machines is purely pathological. That's its real fascination, and the source of its immense disruptive energy. Therrien has become the robotic motion that he describes: an android processor. And not just Therrien, but anyone that breaks the field of the flickering TV sensor and becomes part of the pathological behavior of the "comfort zone." There is no salvation here, only the implications of living at the high-velocity edge of sovereign technology. A theatre of special effects fit for a world of thinking techno-mutants.

Consider the following machinal performances:

PRIMITIVE METHODS OF PURIFICATION: Three machines, "Rail of Greed," "Arm of Life," and "Fetal Cage" engage in

rituals of human purification. These electrified machines embrace the imprisoned individuals in an environment where human choice does not exist. A fourth apparatus pits crash bodies against each other in a game where what is at stake is the rhythm of the weaker performer's heart. A live sound track is provided by the San Francisco percussion/electronic group RHYTHM & NOISE.

INDEX (Machines for the New Inquisition): A 45 foot mechanical crucifix with integrated bodily components. The body of the crucifix is centred around two machines, FETAL CAGE, a mechanical pendulum cage (with occupant) that acts as the heart, and the 90 DEGREE MACHINE (another mechanical cage with occupant) that serves as a phallus. The head of the crucifix, a six foot square neon alpha-numeric display, presents controversial information on current moral and political issues. Historically, the INDEX was a list of books banned by the Vatican Tribunal during the inquisition. It was considered heresy to possess or discuss these books, let alone to read them. This performance commemorated a visit to Phoenix by Pope John Paul whose motorcade passed by the performance site shortly after Therrien's machinal intervention.

TECHNO-MUTANTS: Large electrified body manipulation machines with human passengers subjected to human and cybernetic control. On the TECHNO-MUTANT MACHINE, two bodies struggle against each other on top of a machine, unaware of the imprisoned individual below who is swung back and forth by their actions into electrified steel plates (triggering a 32,000 watt light array thirty inches below the individual). The 90 DEGREE MACHINE continually raises an

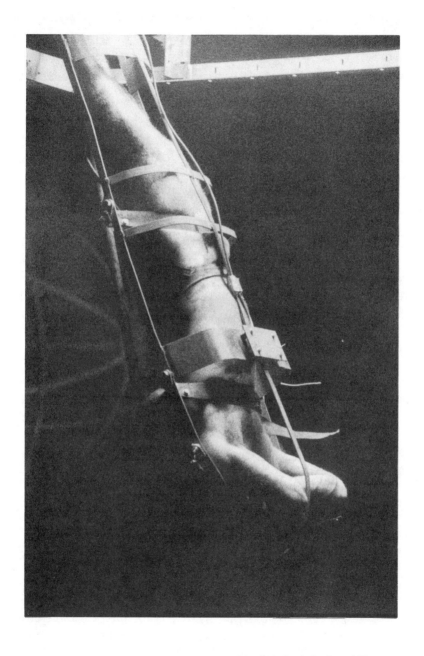

Ritual Mechanics by David Therrien

individual to a prone position, then slams him down into a vertical head down position where the impact (against a steel plate) triggers a loud hybrid digital sample. This is accompanied by a live soundtrack of ritualistic percussion and electronics.

RITUAL MECHANICS: A triad of control relationships involving body manipulation across a field of machines, light, and electricity. A percussionist beating on electrified drums activiates a bank of quart lights. The drums also activate a body manipulation machine, which activates a second machine. This second machine triggers a bank of white light positioned behind the percussionist's head.

Spasm Flesh

To write of the cyber performances of Crash Machines as a body-machine interface is really to miss the point, because the quick mutation of a new body type, the Spasm Body, fit for the age of digital reality is what is really happening here. Just ask Therrien. He has been there: that indefinite but violent moment *inside* the machinal apparatus where the body dipped in and out of a charged electrical field can smell burning metal, be scorched by hot sparks, and vibrate to the humming field of electrified steel plates. In these works, everything is going on. The entire space is bathed in a fast strobe light world of electrical quartz flashes. Heavy industrial music wafts through the air as a reminder of the old rust belt culture from which digital reality seeks escape velocity, and computer screens flicker to life both as a method of automatic control of bodies transformed into

118

servomechanisms and as medical monitors watching the heart-beat and brain waves of performers as an instant read-out of *our* immanent response to technological invasion. This is as close as we can get to the world of the electro-body, that point where we can finally see on the outside of Therrien's suicided body what is happening to us on the inside as we are dipped on a daily basis through the violent, but invisible, field of high technology. As Therrien likes to say: "If you want to show more of the inner body, you need extreme technology."

Therrien, then, as a pioneer of Spasm culture: an artist who has actually made of his body a vibrating sampler machine. A suicided body that actually edits reality by bodily strategies of displacement (in FLESH CHIMES the body becomes a shadowy robotic mannequin), repetition (BOOTCAMP— INDOCTRI-NATION INTO AN ORDERED SYSTEM documents Therrien's fast sequencing through the disciplinary strategies of the U.S. Army), and looping (in ARM OF LIFE a performer is harnessed to a machine suspended from the ceiling, which strikes his chest with a bronze hand, activating the high intensity quartz light words: POWER and PURIS. The machine and "passenger" are slowly lowered into the audience's field of view as the mechanical arm beats in time to a pre-recorded soundtrack).

What Steve Gibson, the android composer, does in digital music through strategies of time-compression, aliasing, phasing, and truncation, Therrien, the android electro-body, does in large-scale architectural performances through the editing medium of his own body, as well as those of cyborg volunteers. Of the *actual feeling* of being a living sampling machine, Therrien says: "When I get in the machine, I think it's time for a good ride now, for an experience of some type. But there is always a certain betrayal. It's a carnival ride at the edge of ecstasy and terror, painful but enjoyable." And why not? Like a cyber-missionary exploring the genetic code of virtual reality, Therrien

makes of his own body a pathological document. An electrified grid of living body parts that smells, breathes, and secretes the suffocating imprisonment and violent implosion of the body as it is fast sequenced through the terror-traced architecture of virtual reality. His digitally scanned body has actually *experienced* the movement of technology from *specular commodity* (COMFORT/VOYEUR) to *icon* (CLOSED SYSTEMS) and thereupon to a *living species being* with its own PRIMITIVE METHODS OF PURIFICATION, RITUAL MECHANICS, and INDEX.

Nietzsche's Vivisectionist in the Ice House

David Therrien's real android function
is this
he has written on the text of his flesh
like a body invader
a Cultural Politics for Techno-Mutants
for spasm culture
where we don't live outside the hot sheen of software
but actually have soft bodies
liquid bodies
scanner bodies
dipped through the electrified
grid of hard

tech

A fascinating and cruel world
of inquisition machines
and flickering medical monitors
that operate
under the double sign

of torture and therapy

Or is it the reverse?
Not the machinery of
torture and therapy
as bi-polar opposites
in the mediascape
but actual sign-twins
mirroring each other to a
dark and immense infinity in
the field
of digital reality

Nietzsche understood it first:
We live in the age of conscience-vivisectionists
of body-vivisectionists (*On the Genealogy of Morals*)
of the reduction
of the body
to a vast experiment onto
which are projected all of the
ressentiment of *our* botched and bungled instincts.

And that is Therrien's fatal mistake
His version of Crash Machines
remains trapped in the modernist dialectic
trying
to recover the (medical) possibility
of technology as salvation
from the medieval principle of
the most beautiful technology (FETAL CAGES)
as torture machines.

Therrien's body knows better
Under the noon-day sun of the

THE ICEHOUSE

BODY

Arizona desert
like Max Ernst's metamorphosis
paintings before it,
it has actually felt
ecstasy and torture
as mirror-images,
the fatal destiny
of the gallery of machines
in the ICE HOUSE

The ICE HOUSE body howls,
screams and
descends into the dark continent of
slaved machines, quartz lighting
and heavy industrial (percussion)
music:

It's always political:
the passing of the Pope's car (INDEX)
the passive voyeurism of TV (DESCENT INTO TELEVI-
SION)
catastrophe as specular activity (COMFORT/VOYEUR)
the ideological index of consumerism (CLOSED SYSTEMS)
sacrificial violence (HUMAN PERCUSSION MACHINES)

And the ICE HOUSE body
always starts cold,
refusing narrative closure.
Just what Therrien wants:
"Crash performances are like sticking your face
up to the windows of a building
and watching a ritualistic machine ballet inside.
It stops.
You don't know what has happened.
You feel uncomfortable and leave.

The vivisectionist is inside you now,
You are the body invader dipped in
and out of an electrified
grid."

COMFORT - Metallic percussive sculpture slaved to high intensity quartz lights. Digital sounds are triggered by the sculpture, with added Nuremberg Trial soundtrack. The audience in Berlin was expecting an American bluegrass band.

HUMAN PERCUSSION MACHINES - Performance/Installation for an unprepared nightclub audience during a "Talent Night" at Graham Central Station in Phoenix, Arizona. A man is suspended from a mobile cantilevered structure that is wheeled into the nightclub. The cantilevered section suspends the man over a stage. A second man then uses the body as a drum, striking steel plates attached to the chest, groin and legs. The electrified grid of steel plates activate high intensity quartz lights and digital sound triggers.

Maybe we are all
the ICE HOUSE body
now, the body as a sampler machine
editing and re-editing the spastic loops
of virtual reality, a flared out
theatre of S/M
that has the digital codes
of the gallery of machines
tattooed on its flesh.
A world of body invaders

WE'RE SPEEDING DOWN THE
HIGHWAY ON THE WAY TO INTENSIVE CARE

like a silent tribute to Kafka
who strap on
the digital techno-skin
of the virtual universe,
living at the edge of cruelty and seduction
howling the ecstatic lament
of Crash Freedom.

Or, as one writer has put it:
"We're speeding down the highway
on the way to intensive care."

8

Severed Heads: Fetish Freaks and Body Outlaws in the Age of Recombinant Photography

The Fetish Party

Linda Dawn Hammond is a portrait artist of body parts: especially the toes, heads, and stomachs of Montreal's body outlaws who inhabit the psychological territory of the sprawl, that forgotten hard urban edge from Tokyo and Hong Kong to Los Angeles, New York and Amsterdam where bodies are surplus matter to the operation of the techno-galaxy.

3-Part Body Series, Hammond's most prophetic photography, consists of twenty-four vertical studies of body parts in the sprawl. Hammond does not exempt herself from this photographic inquisition, but makes of her own body, personality, and camera a floating body part, forcing each of her subjects to reveal their favorite fetish and then editing the fetishized body into seering images, complete with layered painting (itself a fetishized reminder of cynical time) and large-scale mounting on mylar sheets (a sign-fetish of cynical space). The result is a neo-classical optic on the body in ruins: severed heads, distended bellies, arching toes, oiled skin, pirouetting necks, pierced

nipples, chained feet. Hers is a photographic sampler machine that operates as a big, but delicately nuanced, reality editor, feeding on the fetishized bodies of street people, her own as well, and producing in turn a cold romantic vision of *our* trajectory towards a stellar universe of body parts. Everyone comes to the fin de siècle party that is Hammond's *3-Part Body Series: Charlie* might be paralyzed and trapped in a speed-metal wheelchair but he comes for the *fête* complete with an upper body armoured with muscle and inert feet wrapped in chains, topped off with the fascinating sign of the wolf-fetish. *Jimi Imij,* who is one of the best of all the panic hairdressers at *Coup Bizarre,* throws up his head to the sky like a luminescent Madonna; *Darryl* appears at the fetish party under the happy sign of a dancing sado-masochist (his body movements perfectly cut to the mood of his leather-collar neck and the chain twined through his fingers); *Kim* makes her photographic entrance rubbing the old-fashioned signifier of fishnet against ripped steel-tipped workboots; even *Garth* strips down to reveal an oiled body, all the more beautiful for its veneer of the flesh sacred; and, finally, *Pierre* makes of his body an endless sign-slide between snakes and cocks.

Mix and Match Bodies

Hammond can be such an observant student of sampler culture as a big fetish party because she is the photographer par excellence of mix and match bodies, of that digital reality where the body is blown across the social field, and dispersed into swirling eddies of body parts. Here, the body has a surface veneer of unity, but an underlying reality of radical dismemberment. The mix and match body, therefore, as the new body type for the age of recombinant culture, that era in which the body is

already surplus matter to its own techno-skin. In Hammond's photography there is no trace of nostalgia for the fictitious concrete unity of the old modernist body, and certainly no hint of a happy conspiracy of interests between seemingly opposing tendencies towards decomposition and recovery. Instead, we are confronted with photographic thermographs of the ecstasy of decomposition, sacrificial scenes where the fetishistic debris of the mediascape is sampled as a way of transforming the irreality of body bits into an indifferent, but no less charming, universe of circus performances.

Perhaps it might be said that Hammond is the Dianne Arbus of the body mutant. With this difference. Whereas Arbus photographed the hidden world of circus freaks for their incipient signs of transgressionary value, thus evoking the excluded and silenced values of bourgeois culture, Hammond photographs the freak within, the freak fetishist. Not excluded freaks, but the subjectivity of the freak triumphant as a resurgent sign of the return of the body from its electronic dissimulation and disappearance. And not freaks as a symbol of transgression, but of the *impossibility* of transgression. Hammond's imaginary landscape of fetish freaks revels in the world of the techno-mutant: they are the advanced architects of a sampler culture where the body knows no other existence than to be at the disappearing centre of the modernist antinomies. Designer freaks who make of the text of their flesh a cynical sign of the disappearance of the body.

In Hammond's liquid photography we can finally see the future of sequenced bodies. Not concrete bodies trapped in the optical carceral of the camera, but an image-reservoir of processed bodies fragmented into floating heads, bellies, and feet that are unified only by totemic fetishes. Some of these fetishes include a Barbie Doll, a tattoo, a ring piercing male nipples, and among others a ripped pair of fishnet stockings. A photographic

127

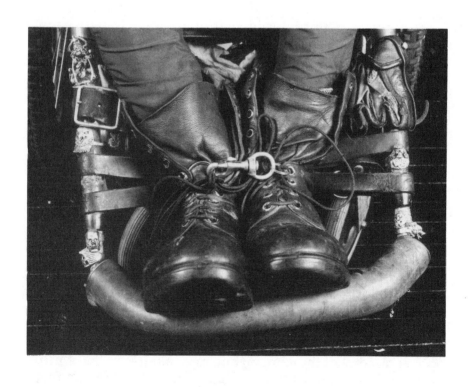

Charlie (Three Part Body Series)
Photo: Linda Dawn Hammond

scanner of shock-wave personalities who have already broken through to the next frontier of recombinant culture, resignifying themselves as fetishistic hybrids. Outlaw bodies living in the psychological space of a new techno-bohemia, undertake an inner migration into the imaginary landscape of the fetish. As a result, the fetish makes a triumphant return, not under the old psychoanalytical sign of repressed sexual anxieties, but as a charmed talisman guiding us into the new continent of the recombinant body. That is, the body as a spinning combinatorial of cynical signs, a sequenced body given temporary definition by decorating its orifices and protuberances with a violent, but fascinating, code of primitive mythology. The body recombinant, then, recovering a maximal amount of materiality, *dirty materiality*, by turning random body parts into sites of cold-eyed fetishes: oiled skin, big toes, splayed eyeballs, upturned profiles, dancing skulls.

The body recombinant is mutating faster and faster now, spinning off a dizzying array of mutations. Crash bodies possessing no necessary politics nor ultimate meanings, only a violently speeded-up search for the perfect look. A techno-body fit for Cyber-Parties from San Francisco to New York where smart drugs, like *ecstasy*, and a full moon provide the setting for a massive convening of crash bodies. Fetish skins who celebrate their indefinite acceleration into a dense matrix of body parts by donning this month's fashionable screen-effect. Fully cinematic bodies who transform every orifice into a spectral special effect: screen-image eyes, digitally scanned ears, architecturally layered hair, tattooed heads, stud lips. A carnival of decomposition (of the old body) where the past rituals of fetishism are first scavenged for their totemic signs, and then hard-wired into the skin of techno-mutants as its emblematic screen-effect.

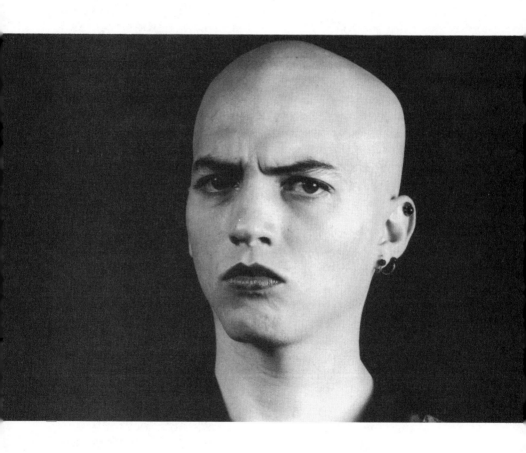

Francis (Three Part Body Series)
Photo: Linda Dawn Hammond

Hammond's photography, therefore, is a genetic sequencer of the body mutant. Thinking through to the vanishing centre of the body recombinant—its production of hybrid bodies populated by dismembered, floating personalities—her photographic optic clearly displays the combinatorial logic of the latest generation of sequenced bodies. No longer passive recombinants scanned by the mediascape or mutant hybrids, these bodies are playfully indifferent circus androids, a carnival of outlaw bodies, who fetishize the question of sexual identity itself.

In Hammond's imagination, we actually probe the future of the sequenced personality, and find a doubled moment. Part floating recombinants, but also part ritualistic gesture. Techno-mutants that make of themselves photographic hybrids, all the more to be redoubled under the ambivalent sign of the floating fetish. Not a return to romanticism where fetishistic resignification would represent a recovery from a fatal decomposition, but something very different. A cultural combinatorial where tendencies towards decompositon and recovery splay outwards simultaneously, migrating across the opposite pole as a privileged moment of sacrificial violence.

No longer a world of romantic primitivism, but primitive recombinants. These are the first of all the bimodern bodies, reclaimed at the violent edge of simulation and primitivism. Here, the fetish is a charmed talisman, taking us directly into the doubled logic of the virtual body.

Barbie Gets a Penis

What is the meaning of the bondage fetish in recombinant culture? A ritualistic return of the primitive? A condensation of the psychoanalytics of desire into a floating object-cathexis? Or something different? The bondage fetish as an anamorphic hinge between primitivism and crash culture. A gateway through which the recombinant body time-travels across the glittering galaxy of its own lost remainders.

The Barbie doll is a perfect talisman of crash culture. Itself a hologram of sampler society, Barbie is attached to Martial's leather belt as a sign of a virtual sex that never was, a little sign-switch in the theatre of sado-masochism. And Barbie just loves it. For she had long ago tired of her disciplinary role as a California mutant, and wanted desperately to be set free. Not to be Barbie any longer, but to reverse the Barbie "look" into its opposite sign: a monstrous double, a site of iconic innocence, yet inscribing sexual transgression. This is what Barbie always really wanted, and on behalf of which she was prepared to abandon the dull and affirmative model of an obsolescent female beauty. That is, to become a Barbie fetish that can be so fascinating because she pulsates in opposite polarities: repressive cuteness and the liberation of male bondage wear. Barbie, then, as a sign-slide in which even doll icons seek to regenerate themselves by going over to their opposite number. Here, Barbie grows a penis.

Barbie then as enjoying one last fashion vogue as a sexual sequencer, ordering and reordering the transgressive stratagems of all the games of male bondage and discipline. And what better bondage fetish than Barbie? For she was always a perfect disciplinary clone: blonde hair, long legs, pert face, and trendy Valley clothes. Barbie, as America's bondage Queen, is just perfect to hold together the 3-part body of the pleasure of male bondage.

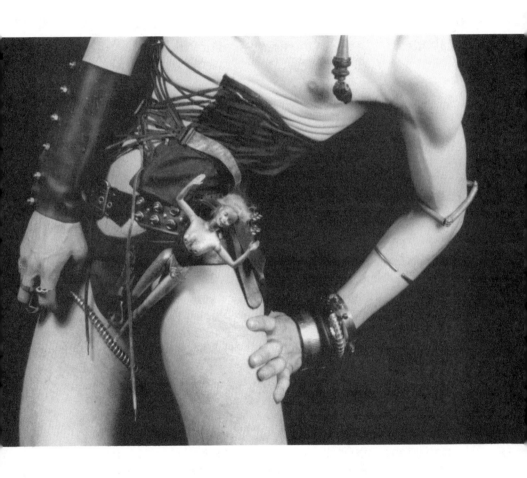

Martial (Three Part Body Series)
Photo: Linda Dawn Hammond

The Big Toe

Remember Bataille for what he *doesn't*, and maybe cannot, tell us about the big toe in the era of spastic culture:

The big toe is the most *human* part of the human body, in the sense that no other element of this body is as differentiated from the corresponding element of the anthropoid ape (chimpanzee, gorilla, orangutan, or gibbon). This is due to the fact that the ape is tree-dwelling, whereas man moves on the earth without clinging to branches, having himself become a tree, in other words raising himself straight up like a tree, and all the more beautiful for the correctness of his erection. In addition, the function of the human foot consists in giving a firm foundation to the erection of which man is so proud (the big toe, ceasing to grasp branches, is applied to the ground on the same plane as the other toes).

But whatever the role played in the erection by his foot, man, who has a light head, in other words a head raised to the heavens and heavenly things, sees it as spit, on the pretext that he has this foot in the mud.

Although within the body blood flows in equal quantities from high to low and from low to high, there is a bias in favor of that which elevates itself, and human life is erroneously seen as an elevation. The division of the universe into subterranean hell and perfectly pure heaven is an indelible conception, mud and darkness being the *principles* of evil as light and celestial space are the *principles* of good: with their feet in the mud but their heads more or less in light, men obstinately imagine a tide that will permanently elevate them, never to return, into pure space. Human life entails, in fact, the rage of seeing oneself as back and forth movement from refuse to the ideal, and from the ideal to refuse — a rage that is easily directed against an organ as *base* as the foot.[1]

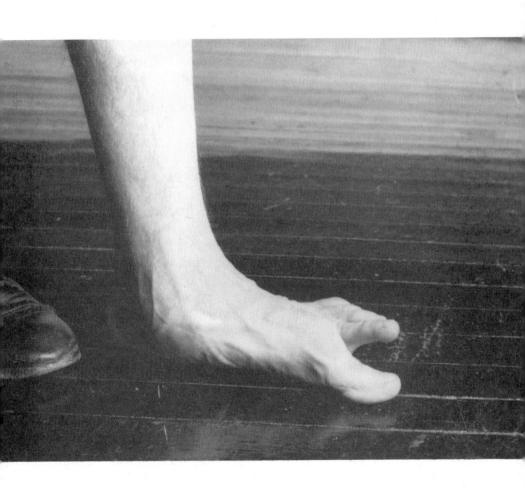

Thomas (Three Part Body Series)
Photo: Linda Dawn Hammond

TOE

LICKING

We are no longer living in the age of Bataille's "Big Toe," of a permanent elevation beyond the mud of experience to the pure space of virtual reality, from refuse to the ideal. That is what made the appearance of the big toe such a scandal in the modernist episteme. It represented a refusal of the light head of the sun, and an affirmation of the sovereignty of the base.

But now it's just the opposite. The big toe can be so valorized today because the surrealistic doubling of the body between decomposition and resignification has lost its meaning in spastic culture. Perhaps the big toe could have assumed its scandalous proportions just because the *base* no longer exists as a fatal scission of the "glory" of the sun. This would indicate that the big toe has migrated from the mud of experience becoming an eye, a head, a recombinant ear, a gaping mouth. In this case, the focus on the fetishistic sign-value of the big toe is a trompe l'oeil deflecting the eye from the spraying of the body mutant by all the secretions of base experience. Here, the big toe can retain its fascination only as a schizoid fetish implying the impossibility of delimiting the pure space of specular value from the nostalgic materialism of the body recombinant.

And what of the appearance of seduction? That would be reduced to a theatre of the burlesque, all the more piquant for its absence of division between light and base. We no longer inhabit the universe of seduction, but that of crash bodies, and crash big toes too, which is precisely what makes Bataille's description of toe licking so delicious. It's a nostalgic reinvocation of a toe sex that can be so charming, because the object of its desire, the big toe, has long ago vanished, just disappeared, into the universe of cynical signs.

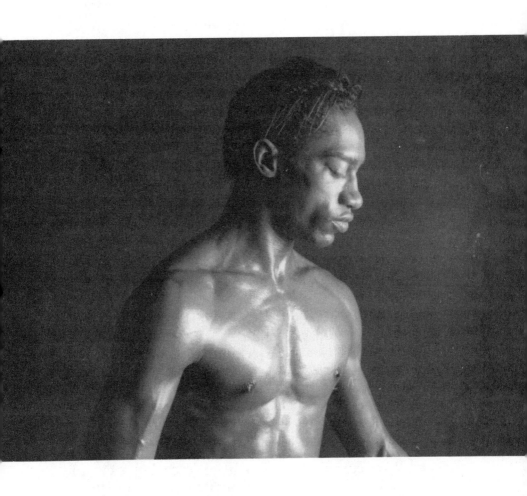

Garth (Three Part Body Series)
Photo: Linda Dawn Hammond

And so, remember Bataille as the Patron Saint of Lost Fetishes:

> As for the big toe, classic foot fetishism leading to the licking of toes categorically indicates that this is a phenomenon of base seduction, which accounts for the burlesque value that is always more or less attached to the pleasures condemned by pure and superficial men...A return to reality does not imply any new acceptances, but means that one is seduced in a base manner, without transpositions and to the point of screaming, opening his eyes wide: opening them wide, then, before a big toe. [2]

Liquid Crystal Skin

The application of ointment to the skin is perfect for the body recombinant. A sign of the vanishing of the skin as a symbol of separation between air and blood. A liquid materialism of the skin that is thereby transposed into a sliding signifier, one that glitters, slides and glistens. Perfect for a dry technology and a dry age: an era of sex without secretions where the body too loses its natural lubricants as it is processed like speed metal across the screen and the networks of virtual reality.

There can be such emphasis on glistening skin today because skin only exists as a eye high-liner of the vanishing body in recombinant culture. Not skin any longer, but a complex combinatorial of the fleshly body that serves as a turbulent signifying machine of all the passing values: steroid meat frames for body builders, annointed skin in fashion advertisements, liquid membranes on display in strip parlours. And to the question: What is the future of skin in virtual reality? it might be replied that skin has one last technical function as a liquid crystal array. Liquid skin for the liquid self, where images of

138

possible selves can be stored in memory chips, and then displayed across the screen of the flesh. And not only of one's own self, but of the mutation of the body across the spectrum of the stars. Hologramic images that blend in with or flare out from the environment architecture, producing a seductive display of liquid crystal images.

Brain Tap

Photographic images of the head can be so fascinating because it does not exist. Perhaps we have finally exited the old (Western) world of a head-centred body, and a head-centred universe, and have gone over to the image of the liquid body: the telemetried speed-body without a centre, where fetishes have lost their referential value, reappearing now only as video-tattoos inscribed on an indifferent flesh.

And why not? In the age of artificial intelligence and robotic telemetry, the brain has been severed from the head and with it thinking has been exteriorized from its geographical locality in the skull, taking up residence in smart machines, digital feelings, and sampler architecture. In this case, we float in the ocean of liquid intelligence, one that has data as its content, pattern-recognition as its emblematic sign, scanning as its telematic function, and telemetried information as its evolutionary destiny.

Consequently, the optically privileged head can finally return to prominence as a material sign of that which never was. Having lost its original philosophical claim on earthly rationality and been abandoned by the telemetried brain that long ago blasted into orbit around the skull, the head can make one final appearance as a deserted bodily protuberance, ideal for coloni-

zation by passing fetishes. Hence, the shaved head with its dead-eyed stare as a brilliant, but vacant, demarcation between the bright moon of the skull and the sky of the enclosing galactic night. The fetishized head, then, as a doubled sign of desertion: of the deterritorialization of the brain as it up-links with the satellised world of metabolic intelligence; and of the dehistoricization of the skull that has about it the desolate feeling of those long-vacant, but recently, discovered moons of Venus. Not so much heads any longer, but brain taps waiting to be fetishized.

This image is ideal for the era of the floating head, where brain patches can be grafted onto any of the body's organs. A viscous universe of molecular chips, thinking ears, intelligent viruses, and data eyes. No longer immobile intelligence grafted onto permanent personalities, but brain patches that can be downloaded to fit the passing circumstance. Dadaist intelligence for party functions; Darwinian brain turbulence for business; mood intelligence for the liquid flows of the telematic body. MIDI brain sequencers as a new comfort level for the body mutant, always exteriorized, capable of parallel processing, and yet intensely intimate to their virtual users.

Perhaps one day the MIDI brain will require a human face, and on the empty text of that face will be inscribed the historical signs of memory, of an earthly autobiography. Maybe that day has already occurred, and what we see in Francis' head is the chosen face-plate of the great reversal of brain taps: the re-energized head that can be such a fetish-object because it is a third-order simulacra of spasm culture. Not the antiquated organic head nor the discursive skull, but the perfect cynical head. A beautiful skull-like image that can be a vanishing sign of a face without memory before the age of brain taps, and of a head cavity without (scanner) intelligence before the time of liquid brains. The optically framed head, therefore, as the last and best of all the photo ops.

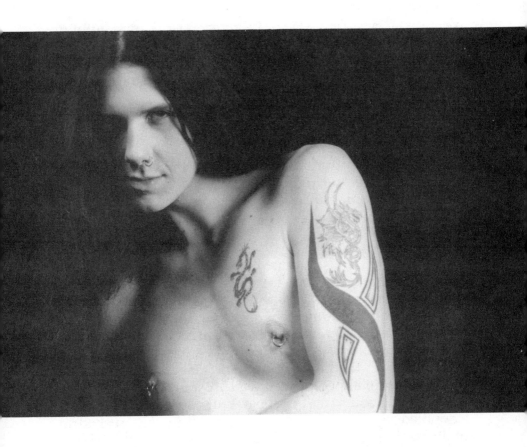

Pierre (Three Part Body Series)
Photo: Linda Dawn Hammond

Liquid Crystal Sex

A new magazine, *Torn Scrotum*, is circulating in the underground. It adopts this cultural strategy: to resist the operations of a cynical power by making of the (male) body an ambivalent sign of abnegation and aggression. This male body functions like a cracked mirror, beaming back to the pulsar of power its distorted reverse image. No longer the self-contained and tightly inscribed phallocentric body, but the body primitive, scarred with ritualistic tattoos, pierced nipples, and boa constrictor penises. The body in ruins, therefore, for the digital politics of ironic immersion and ironic distancing. Here, the body is a field disturbance, ripping apart the epistemological veil of normalcy in favor of the sweet excesses of self-decoration and self-mutilation.

The scarred and mutilated body is the real language of ideology in the age of body invaders. The body becomes a war zone with its own *logistics* (nipple rings, tattooing, snakes, skin), *tactics* (the politics of imminent reversibility), and *strategy* (transgression through sub-suicidal excess). Indeed, the body *is* a war machine, with nipples as a theatre of bondage, and a penis entwined with the mythic power of snakes. In this portrait, nipples can finally be pierced as the ears of the recombinant (male) body because the boa constrictor has the deliciousness of a doubled sign: simultaneously a sign of the penis crushed and of the penis aggressive. The body, then, as liquid crystal sex, a nowhere zone oscillating between inertia and violence.

9

SPASM: THE SCREEN
EXCREMENTAL TV

Arthur and Marilouise Kroker

Today we live in the age of excremental TV. No longer TV under the old sociological sign of accumulation with its coherent division of TV aesthetics into strategy (official culture) and tactics (outlaw culture), but TV as already under the Bataillean (excremental) logic of disaccumulation, self-cancellation and self-exterminism. TV, therefore, as a waste management system: an indeterminate stockpiling of dead images and dead sounds that threaten to suffocate us with their inertness, and on behalf of which the mediascape functions as a vast aesthetic machinery for managing the discharge of image effluents and for recycling all the waste products, televisual subjects most of all, produced by excremental TV.

So then, four anal flows in the image-discharge of excremental TV: sacrifice, discipline, surveillance, and crash.

Sacrificial TV: That's TV functioning as Nietzsche predicted in the prophetic theses of *On the Genealogy of Morals*. In the age

143

SACRIFICIAL TV

of the virtualization of the flesh, TV functions as the key televisual site for the discharge of ressentiment onto the public situation. Sometimes the sacrificial scapegoating of the televisual self as viewers deliver themselves up as a joke (*America's Funniest Home Videos*) for consumption by the mediascape, made all the more delirious by the use of the camcorder for purposes of self-abnegation and self-humiliation. At other times, the sacrificial scapegoating of vulnerable minorities (African-Americans, the poor, Queer Nation) as TV dissolves into a sacrificial tableau, naming the victim of the day and dictating the terms of the sacrifice. Consequently, TV shows like CBS's *48 Hours* and *Cops*, with their incessant scenes of African-Americans being hunted down and arrested for drug offenses as a source of a massive psychological discharge of the spurious anxieties and fears experienced by the surrounding white suburban population as it relives nightly the traumas and fantasies of the TV security state. In sacrificial TV, the moral coherency of the ruling majority in liberal culture is assured by the televisual scapegoating mechanism, with its nomination of a purely accidental range of victims, their instant demonization, and their televised sacrificial punishment. No longer TV as a discourse between elites and the silent majority, but a deeply libidinal machinery linking ascetic priests (TV anchors) and the majoritarian population of passive nihilists into a scene of sacrificial violence.

Disciplinary TV: In the age of liberal fascism with its globalization of the language of technical willing, TV functions as a medium for intensifying the disciplinary state, which projects power outwards into the consciousness of its televisual subjects. TV does not operate as much according to the disciplinary codes theorized so eloquently by Paul Virilio, where TV acts as a war machine with its threefold logic of strategy, tactics and logistics. Disciplinary TV in the age of excremental culture is all about disappearances: a negativeland of fractal subjects,

144

recombinant bodies and memory splices where the aesthetic machinery functions to assure consent to the dynamic language of technical willing. And not just to the vision of technology as freedom, but now to an improved vision of TV as a *healing process* with life-giving powers: a universal and homogenous therapeutic televisual process that operates according to the following medical model: scanning of the televisual body for viral infections (morning news with its catastrophe theorems and crisis-ridden language), social therapeutics for the alienated televisual subjects (the afternoon talk shows like Oprah Winfrey and Donahue), and the chloroforming of the recombinant body before it its discharged into its sleep state (the nightly talk shows, Jay Leno, David Letterman, etc). TV has become a disciplinary machinery where technology speaks in the name of life, not death, according to the model of social therapeutics, not blood, and where the key ideology is seduction, not coercion.

Surveillance TV: This is the world of the camcorder where Marx's "priest" finally comes inside the televisual subject like a cancerous tumor, and everybody becomes their own surveillance camera. Sometimes, surveillance of the "Other" as the camcorder illuminates the previously invisible region of the actual operations of power. Note, for example, the global witnessing of the Rodney King beating with its twofold message of (explicit) police brutality and of an (implicit) repeated televisual warning to African-Americans that they have good reason to fear encounters with the security state. At other times, surveillance of the previously undocumented regions of the "self" as the camcorder zooms in on the catastrophe zone of the excremental family: see Johnny's first birthday, see Johnny's first masturbation, see Johnny's first toilet training. Here, the camcorder is the privileged televisual medium of excremental culture. Less about documentalism (although that too), it is really a viral weapon in the oedipal struggle, that point where the unhappy

union of Daddy-Mommy-Me is turned into a surveillance zone for future punishment: Mommy's camcorder invasion of the privacy of her children, and Daddy stores up televisual images for future ridicule.

In surveillance TV, the optical power of the camera finally leaves the static, centralized region of the TV studio, and becomes something fluid, polymorphous, and immensely popular. The camcorder, then, as the newest member of the televisual family. Every Mommy becomes an archivist of the moving image of family history; every Daddy, a potential film director; editing and reediting the script of the family story, with its jump cuts, montage techniques, and Godardian reversals. And every little Me, an unlicenced actor in the unfolding logistics of perception into which the excremental family has happily disappeared.

Panic families, therefore, where the will to visually record family life is in direct relation to the breakdown of unitary family relations. When the family dissolves into a lap frame of TV life, the cinematic screen finally goes liquid and actually enters the body. Life becomes an eternal TV game show, an optical trompe l'oeil, a perfect scene of cinematic derealization with 1,000 hour camcorder childhood memories, with its endless stockpiling of dead images which no one will ever look at because they are really about the erasure of experience, the extermination of memory.

And what about the future of the children of the camcorder generation, that televisual generation of whom it might be said: "This is Your Life? Or is it? " Perhaps for them, a new technological advance in the age of digital TV will emerge with the appearance on the market of the video interceptor: a new technology for digitally resequencing all the debris of family memories. Here, Daddy can be made to play on the floor in the role of the baby, Mommy can be cloned, brothers and sisters can

be added at will, and all the visual materials of the family album can be digitally reordered. When all the children are like the aliens in *BladeRunner*, with their useless stockpiling of virtual memories, then every child will be free to play the game of staged communications to its final point of disappearance: that cinematic moment when the camcorder finally becomes a way of doing philosophy, of visually recoding all the nostalgic memories of the oedipal family. And why not? The generation of "cam-children" has been robbed of its memories by its forced enclosure in the family script, actually given the wrong televised memories by the cinematic realization of its parents. These never were their memories, but the false images of their parents. A kind of televisual prison for the future of the virtual child, where even the ability at maturity to reflect on the past of family life has already been scripted in advance. So then, for the future camcorder generation, the direction of political rebellion is clear: *Discover the inner camcorder*, the camcorder that has been suppressed by the disappearance of subjectivity into the distended eye of the Oedipal Family. Fight surveillance TV by going vague, by using the video interceptor to cross the stock footage of the old camcorder family, to digitally resequence memories of family life until the desired digital family finally emerges.

Crash TV: The inertial tendencies at the disappearing centre of excremental TV are overcome by the principle of *reenergization through violence*. On American college campuses, the most popular underground video these days is *Death Video*: actual death scenes, ranging from penal executions to corpses pulled from car wrecks. It's the same on television where the newest hit shows have to do with America's Biggest Crashes (*Eye Witness Video*) or, for that matter, the network news where the screen is energized again and again by all the passing scenes from splatter culture (starvation victims, body fragments) to plane crashes (human debris from all the big catastrophes). In Crash

147

TV, the metaphor of the screen can be energized by the metonymy of the catastrophic event because the ruling rhetoric of excremental culture is *cynical seduction*: the crossing of the syntagm between metaphor and metonymy, between rhetoric and Catastrophe, a quick reversal that assures the fading attention of televisual subjects. Like a stellar blast from the darkest regions of outer space, Crash TV radiates the dark mass of the population with the ferocity of its explosion, as much as it fascinates with the primitivism of its imagery. In Crash TV, we suddenly exit modernist culture, and enter the unknown terrain of the *postmodern primitive*, that territory where all the postmodern technologies involved in the virtualization of the flesh merge with the most primitive of human emotions: fascination with the smoking wreckage of the crash, chilled paralysis at the sight of the Catastrophe, one last joke as the plane falls through the air in its death spiral. In the world of the postmodern primitive, what fascinates is not coherency or the accumulative logic of the stabilized image, but the ripping sound made when the walls of virtual reality implode under the fantastic pressure of surrounding events, and we are suddenly swept away in a catastrophic free-fall through all the surrounding space. Splatter culture is the final destiny and fatal dream inspiring the viral growth of Crash TV.

10

SPASM: THE END
BAUDRILLARD RECOMBINANT

"panic has subsided and simulation has lost its seduction"

J. H. Mohr

Crushed Subjectivity

Baudrillard is that rarity of a thinker who has lived to see his theory become the world that he thought he was only describing. If we can speak of the "Baudrillardian scene," that is because we live now in the age of the simulacrum, in a consumption machine organized as a "mirror of production," in a culture driven onwards by the siren-call of seduction.

To understand Baudrillard, therefore, a double process of self-discovery is necessary. First, we enter deeply into the world that has become the mirror of Baudrillard: its politics (sacrificial), its technology (virtual), its subjectivity (fractal), its culture (the simulacrum), its economy (imminently fungible and always reversible), and its ideology (viral positivity). And second, to the extent that our own subjectivity has become a living sign of the simulacrum, then we also undertake an inner migration: an intellectual voyage where the Socratic admonition to "know

149

yourself" takes place now only in the doubled , and ultimately reversed, sense that self-recognition is really about discovering anew the shock of the real.

In the age of Baudrillard, private autobiography recapitulates public history, just as much as culture is a direct psychological read-out of crushed subjectivity. Here, the "self" most of all plays out the "fatal strategies" of a society that can be manic in its obsessions because so deeply infected by the will to inertia, mesmerized by the recovery of a sense of the real (Reality TV) because so seduced by the illusional space of irreality, and driven by the sacrificial dream of viral purity because so deeply infected by the culture of dismemberment. And to the extent that subjectivity is a playground of the culture of dismemberment, so too the public order of the simulacrum is a vast displacement onto the public scene of all of the processes of self-denial and mutilated emotion typifying the movement of a culture of seduction, without feelings. The Baudrillardian scene is populated by the viral subjectivity of zero-culture and by the virtual seduction of recombinant culture.

Zero-Culture

What is the significance of Baudrillard's thought in the age of "ethnic cleansing"?

A whole world consumed now by a delirious desire for purity: ethnic purity (the "Brotherhood of Serbs"), national purity ("Germany for the Germans"), purity of bodily fluids (mandatory drug testing), and purity of social relations ("Good Family Values"). If today there can be such intense fascination with the recuperation of a purified world, with a culture bleached of difference, might this not indicate that we are really seduced

by the reality of an impure, "dirty" world: toxic bodies, outlaw sexuality, corroded relations, chemically-coded subjectivity. In this case, the drive for purity would have about it the nostalgic quality of hysteria that seeks to project onto the bodies of an accidental range of victims, from inhabitants of inner-city ghettos in America who are reduced to sacrificial scapegoats for a TV culture driven by the second-order thrill of virtual participation in *Cops* to Romanian Gypsies who can be expelled from a contemporary Germany where right-wing skinheads express the anger and suppressed resentment of the population as a whole.

To speak, then, of the world as the Baudrillardian scene is to articulate a primary political question: What does understanding Baudrillard have to tell us about our present situation of living out the end of the twentieth-century midst the excesses of zero-culture.

Zero-culture? That's the present age of high-intensity reactionary movements: a zero-culture where politics, culture, society and economy are driven backwards to the illusive, and always unobtainable, gold standard of zero. A cold, and deeply intertial, point of no difference, where just as in mathematics what is privileged is the fatal cancellation of the sign.

Zero-tolerance: the famous "war on drugs" where what is really targeted, particularly in the United States, is the population of African-Americans who become sacrificial victims, actually scapegoats, for all the anxieties of suburban white populations.

Zero-dissent: that's the politics of backlash against women as well as against the sexual rights of gays and lesbians. A sexual war that can be waged by the hysterical male against the social gains of the women's movement, and most certainly against the

outlaw sexuality of gays and lesbians.

Zero-difference: that's the politics of "ethnic cleansing," a fundamentalist reaction against the *differend* of immigrants, ranging from the war cry of "Germany for the Germans" by attacking mobs of skinheads (supported by 51% of the German population who support the statement "Germany for the Germans") as they burn down immigrant hostels and Le Pen's *National Front* in France who can be vociferous in their denunciations of French immigrants because their's is a return to a social policy of the degree-zero on the question of ethnic difference.

Zero-bodies: that's the haunting memory of the "disappeared" of Chile, Guatamala, Ecuador, Argentina and Peru. Not simply the exterminism of ethnic difference as in Europe, but something more perverse. A state policy of disappearances, where the body itself becomes a sign of annihilation.

And finally, zero-inflation: that's the class war that is waged everywhere against the poor, the unemployed, and certainly the working classes. Not so much an economic policy for a future prosperity as an ideological campaign of class suppression where employment itself becomes an instrument of power.

Zero-culture, therefore, as our present. That political circumstance where ascendant forces of fundamentalism initiate warfare in the languages of race, class, sexuality, labour. Not so much the disappearance of the referents, but their recuperation under the banners of reaction. A politics of reaction that is waged in the sacrificial language of scapegoatism with appeals to spurious identity, and that can be so unrelieved in its intensity because it is in the way of a recuperation of illusory referents.

Cynical Sacrifice

If Baudrillard is correct that we live in the days of the disappearance of the sign, two readings are possible. In the first case, fundamentalist politics is in the way of a return of the primitive, a nostalgic retrieval of the after-images of the big referents that have lost their appeal. In this situation, our history would be that of a politics of pure reaction, one that seeks out the white-heat of pure signs because here there is no longer any possibility of purity. A politics, then, of *viral purity* that can be so aggressive in its practice of scapegoating and projection because of its imminent acknowledgement of our deep immersion in the reality of a *dirty* world: invested with difference, from sexual difference and ethnic difference to class difference, and all of this a celebration of the impossibility, and ultimate undesirability, of purity. Or, in the other case, there can be such a violent recovery of pure referents because we already are living on the other side of death of referents. Not sacrificial violence, but cynical sacrifice. A society of dismemberment typified by the return of *mimesis* as cultural kitsch. A cynical culture where the referents can be recuperated for one last act of mythic nostalgia: one that has about it only the signs of decay. No longer a politics of sacrificial violence, but something much more ominous. A politics of cynical sacrifice where knowing that there is no longer any substantive aim to sacrifice, that the gods of *mimesis* are finally dead, still, like Nietzsche's nihilists before us, we would prefer to go on sacrificing rather than not act at all. Suicidal sacrifice, then, of our bodies, culture and politics as a certain sign that we are living now in the days of the death of ritual and the radical disenchantment of the horizon of signs.

Or maybe it is something different. If we can experience so vividly the politics of cynical sacrifice, perhaps that is because

CLIP CHIPS

we have already moved at warp speed into another history, into another geography of culture. Beyond the age of the sign to virtuality, beyond simulation to recombinant culture, beyond the era of the *merely* technological to the era of bio-technology. In this case, the twin politics of viral purity and cynical sacrifice can drench the world with their ferocity because they are already a *mise-en-scene:* a fatal sign of that which has existence now only as a faded reminder of a previous stage of political history.

Recombinant Culture

We no longer live in the age of simulation, but of recombinant culture. That point where the model of simulation severs its relationship with the social, undergoing a fateful merger with the language of genetics. A world of bio-power where technology becomes flesh.

And why not? It is no longer technology as commodity-form or as icon, but as a living species existence. That is the real meaning of virtual reality. Technology comes alive, actually acquires organicity. First, the animal species, then the human species, and now the technology species. And none of this understandable any longer in the language of the social (that is how humans speak about themselves), but in the language of bio-technology. When the machines finally begin to speak, it turns out that they have their own aesthetic (virtual reality), blood (electricity), logic (combinatorial), evolutionary principle (chaos theory), diseases (worms and viruses), medical thera-peutics (computer vaccines and disinfectants), and cellular membranes (electronic networks). When technology comes alive as a species-being with its own evolutionary processes and methods of adaptation to *its* alien environments (human

nature and non-social nature), then we can finally speak about *living* virtual reality, about virtual reality as the first of all the purely electronic life-forms.

In living virtual reality, it is to the great order of biological discourse that we should look. No longer simulation cast in the dead language of sociology and certainly not seduction, but virtuality as a product of the conflation of simulation and genetics with chaos theory as its structural principle of change. And not the classical discourse of biology with its Spencerian rules of social determination (classical biology always was the ideology of the social projected onto nature), but the new order of recombinant biology with its epistemological language of teleonomy (the language of *putative necessity*), homeostatic exchanges, digitally driven processes of cloning, sequencing and transcription, and cybernetic hierarchies of control. In living virtual reality, the electronic frontier acquires organicity as all the big referents, having been reenergized algorithmically, return in fantastically recharged form.

In living virtual reality, we can no longer speak of the death of the referents: the death of the social, of culture, of sex. That was always a mirage, hiding the fact that what was really dying was the obsolescent domain of the human, pushed aside by the dynamic will to (technical) life of a new species-form: the recombinant culture of virtual reality.

Baudrillard has always wanted to maintain that we have passed irretrievably beyond the order of the social. But this is only partially true. The outstanding feature of our time is a radical scission of experience. On the one hand, an immense intensification of technological effects associated with the triumphant ascendancy of virtual reality, and then of recombinant culture. Here, we are fated to be the first human beings to witness the emergence of technology as a living species exist-

155

ence. But, on the other hand, precisely because we have been so alienated from the body of technology and rendered so marginal to its systemic functioning, we have fallen back into the dead meat of the flesh, into the chaos of the social, and all this with violent velocity. A schizoid culture, then, marked by two separate worlds, alien and unequal: the recombinant culture of bio-technology where the future is now, and the violently pulsating mass of the social, zero-culture.

Maybe it is no longer, then, the age of the death of the social, but something else. Not the death of the social or of the body, or of any of the great referents, but their fantastic resurrection. Perhaps we are already living in the high noon of Easter Sunday, that moment when the great referents — sex, consciousness, labor, power, truth — suddenly come alive again in reenergized form. Certainly not in the old, and now discarded, form as value-referents of the order of the social, but in a new recombinant form. A delirious time of resurrection-effects, when the great chain of referents are technically resequenced, just like the move from analog to digital music. In this case, we could speak now of recombinant sex, recombinant labor, recombinant power, recombinant society, recombinant culture, recombinant war. A new technological frontier where all the referents can be endlessly recycled in an electronic equivalent of Nietzsche's "eternal recurrence."

Maybe the final destiny of Baudrillard is to become his own fatal sign of disappearance: Baudrillard Recombinant. In this case, the name 'Baudrillard' would detach itself from its old earthly location in Baudrillard's body, becoming instead a talisman, a sign, of the twentieth-first century. Like Dali's image of a future time in which hologramic skies light up with the shimmering images of movie stars, Baudrillard Recombinant would appear to us as the looming, and vaguely sinister, horizon of the next century. Not Baudrillard any longer as a

156

social theorist trapped in the muck of all the culture wars where post-structuralists fight rehabilitated critical theorists to the death, and all this in the environment of a violent viral positivity, but Baudrillard Recombinant as an unfolding story of the (recycled) history that awaits us.

A virtual history where sex is detached from its old chain of referents, first from the body and then from discourse, becoming finally the floating sex of the screenal economy of the body. A time of the floating tongue, memories, desires, and cold seduction. Pure sex without a content.

A digital history where labor is fast sequenced beyond the age of alienation (Marx), beyond reification (Lukacs), beyond simulation (the old twentieth-century Baudrillard), becoming a floating sign in an endless metastasis of exchange-value. In this case, we could finally speak of virtual labor, of labor-value that has no value except as a sign of that which never was.

A nano-history where power speaks in the language of recombinant genetics. No longer a power that approaches us only in the juridical garb of the Daddy's No, but a recombinant power that seeks to harvest all living human and non-human energies for its endless exertion of a will to technology. The will to technology? That's the mobilization of culture, society and economy into the dense and dark matrix of Baudrillard Recombinant, that time where all his texts finally come alive as the language of the real. The ecstasy and catastrophe of *Simulations*, the unnerving fatalism of *Fatal Strategies*, the recovery of the death wish of *Symbolic Exchange and Death* as the "perfecting impulse" of the social, the deserted, but cooly seductive, interior landscapes of *Cool Memories*, and the episodic violence of the absent space of *America*.

A bio-history where war has less to do with apocalyptic violence than with a universal logic of "dissuasion." Like Baudrillard's *La Guerre du golfe n'a pas eu lieu* that can be such a brilliant political analysis of the Gulf War because it is the first of all the military histories of recombinant war. An electronic war that functions as a violent "electro-shock" to prevent all future conflict: electro-shock therapy that is administered by Americans in their role as world "missionaries," and that is aimed at reducing the turbulent scene of global polics to the common denominator of a "degree zero" of politics. If Baudrillard could write that "this war is not a war," that is because electronic war follows a perfectly recombinatorial logic, privileging the televisual and consensual scene of the New World Order.

> Here, the victory of the model is more important than that of the ground. Military success consecrates the triumph of arms, but the success of the programme consecrates the defeat of time. War-processing, the transparency of the model in the waging of war, the strategy of an implacable execution of a programme, the electrocution of all reaction, of any living initiative.... Proper war, a white war, a programmatic war—more bloodly than those that sacrifice human lives. [1]

The Gulf War, therefore, as similar to the opening sequences of *Terminator 2: Judgment Day* where android machines seek out the remaining human survivors for purposes of exterminism. A "pure war" displaying the operational capacity of the war machine, punitive, dissuasive, and violently consensual. An "indefinite virtuality of war" that is bleached of meaning: "At a certain speed, such as that of light, things lose even their shadows. At a certain speed, such as that of information, things lose their meaning." [2] That is the Gulf War, a virtual war definitely occupying a "non-Euclidean space" — "soft war and pure war are in the same boat."

Baudrillard Recombinant

That is the great significance of *La Guerre du golfe n'a pas eu lieu*. It's a theory of recombinant war. If this book can be so contentious in France, it is because Baudrillard's thought has already passed beyond the classical discourse of war to purely recombinant war. It describes a novel human condition, the age of non-war as as time of consensual violence where Clausewitz's dictum of war as "extension of politics by other means" is reversed into a conception of war as the "extension of the absence of politics by other means".

Here, the Gulf War stands as a perfect metaphor for the postmodern condition: a time of technological violence, of deterrence by the logic of dissuasion, of the projection of American power outwards as a way of nihilating the "Other" of Islam. A great shutting down of symbolic resistance carried out by American missionaries who, as Baudrillard says, have a lot to learn about symbolic exchange precisely because of their faith in pure operational capacity.

Or maybe it is something else. Perhaps *La Guerre du golfe n'a pas eu lieu* is our first history of the non-time of the next millennium. A historical horizon that stretches before us like a vacant beach, filled with memories of seductions past and all this filtered through a dusty desultory feeling in the air. Not a happy picture, but not overly sad either. A theoretical snapshot of processed life in the electronic void. If Baudrillard can describe so well a non-war that was fought on the territory of the "pure and the speculative" that is because his mind has already passed through to the unfolding of the human destiny as recombinant culture. That is just what Baudrillard says. If we had a real war, and disinformation, that would be a scandal. Or if we had an unreal war and real information, that also would be a scandal.

But what we have is an irreal war and irreal information. It's a triumph of virtual experience: virtual war, virtual information, virtual victory. Baudrillard's broader historical judgment on the twentieth-century, therefore, as a time of degree-zero politics and degree-zero culture.

And if Baudrillard can write the history of The Gulf War through the optic of a dizzying series of reversals (a war of apocalyptic violence and generalized dissuasion, a pure war that is also a soft war), that is because he has understood perfectly the big crash sequences of the next century. This is one thinker who says no to the great referents, and means it. Not for him a death-bed recovery of all the fatal signs of the West except, of course, in (electronically) recycled form. Third-order simulations, then, as hologram of the next millennium.

It is all finally burned out, broken down into a splatter culture. And Baudrillard is its historical witness. There is no necessary meaning left, only an endless cycle of kitsch. There are no reprises possible of symbolic politics, only the cold language of operational capacity. There is not even any longer a classical discourse of war, or of history or sex for that matter, only their banal translation into the nucleoic strands of a new technological history. Not so much, therefore, the death of the real or the fatal eclipse of the social, but the technological transformation of all the big reality referents, the social most of all, into the new universe of virtual reality.

Virtual Reality

Virtual Reality? That is the global aesthetic so brilliantly traced out in all of Baudrillard's writings. A Baudrillardian scene typified by bio-technology as the language of power. No longer the empire of the sign but of the fast fusion of technology and biology to give rise to living androids as the first citizens of the culture of bio-technology. And everybody knows it. The cultural intimations are everywhere. Think of Bruce Sterling's *Islands in the Net* where the electronic Net mirrors back to us the banality of the human condition.[3] In the "sprawl," prosthetics hard-wire the body telematic, cyberspace is experienced as a "consensual hallucination" that can be jacked into by trodes circuited to liquid brains, and everyone yearns to be a shock-wave rider in the real world of digital data. Or consider the fate of the replicants in the newly released director's version of *Blade-Runner*, where memory chips of a past that never existed are routinely programmed into advanced versions of cyborgs, and where, in the absence of being tested, you can only remain ambivalent on the question of your own membership in the species of replicants.

Perhaps the world intimated by the cinema and literature of popular culture, from *Robo-Cop* and *Lawn Mower Man* to *Total Recall*, has already happened. Maybe we are already space-travellers in the future as now, habituated, maybe even addicted, to body prosethetics, accustomed to spasmodic consciousness as our floating eyes channel surf across the electronic waves of the universal media archive, and seduced by the image of the cyborg: part-machine/part-human/part-god. A world of bio-technology where power can finally speak to us in the therapeutic language of 'yes,' and all this because the will to technology perfectly conflates now with the preservation of the human species. A life-affirming techno-power that operates at the interface of computers and the body, in fact at that point where

computers go molecular in the form of nano-technologies and begin to swim in the arterial networks of the body telematic.

In the empire of bio-technology, we finally pass beyond the order of the sign. For this is a purely virtual world, a designer world of recombinant genetics, where the operant languages are those of cloning, sequencing and transcription. And make no mistake. We are not speaking simply of cellular experiments in the laboratories of hard science, but of the language of the laboratories of recombinant genetics as incubators of a new language of social and political power. A bio-power that resequences the world into the long retrobasal strips of cellular genetics, defines the perfecting, or deviant, cultural code, transcribes the code through the liquid language of the media, and then reconfigures the cultural matrix. Not so much the "Human Genome Project" as the extension of the language of viral positivity into the world of biology, but the "political genome project" and the "cultural genome project" as the resequencing of the *codes* of the human species as the transcription of the human by the purely technological. A world of the recombinant sign where semiology is infected by biology, resulting in a viral invasion of the language of semiology. In recombinant culture, the language of postmodernism finally comes alive as the code of a culture that can accept so easily the death of the *grand recits* because it is already living through the newly emergent history of *recombinant recits*, of the capillaries of the bio-sign.

And if we can speak of bio-technology with its viral operations of cloning, sequencing and transcription of the human genetic *and* cultural codes, then this also implies a change in social practices. If, that is, we have moved beyond the sign to bio-power, beyond signification to the recombinant languages of genetic manipulation, then perhaps we have also ruptured with the simulacrum in favor of the bio-apparatus.

The bio-apparatus? That is the universal media machine as a vast operation in pure cybernetics: television as a bio-apparatus for cloning and transcribing enzymatic elements of the cultural code; electronic politics as a bio-apparatus for remaking the body politic under the sign of liquid power; music as a bio-apparatus for innoculating the digital world of floating bodies and floating minds with emotions detached from context, desires deterritorialized from seduction, and images *morphed* from patched sequences of cultural memory archive. A fully recombinant culture that functions virtually because it has no necessary content. Indeed, a recombinant culture that has in its most intensive features no content at all: only a premonitory horizon of Pure TV, Pure War, Pure Bodies, and Pure Culture. A digital universe where morphing replaces seduction, bio-technology the sign, and the ecstasy and dread of recombinant culture the fatal, and always nostalgic, play of symbolic exchange.

In these, the declining hours of the twentieth-century, the legacy of Jean Baudrillard may be exactly this: to have left us in a twilight zone between the disappearance of symbolic exchange (except as cultural kitsch in a time of cynical sacrifice) and the reappearance of the empire of signs (from electronically-mediated politics to 200-track subjectivity) in the age of virtual reality. When technology becomes art, then our fate is that of witnesses to the unfolding once more of a radical *technological* reinvention of the world. But having rubbed Baudrillard against recombinant culture, we are not left defenceless against the twin poles of technological fatalism and techno-fetishism. After all, the Baudrillardian "method" — this straining of the theoretical imagination through the violent screen of techno-culture — provides us with a new, and powerful, vocabularly for lighting up the previously hidden continent of virtual reality. Not just words, but a vocabularly of seduction, for tracing out the hidden reversals, and contradictory meanings, at the vanishing

centre of technological society. A hyper-method for under-
standing a century that opens up before us like an abandoned
drifting wreck in outer space, moving at the speed of light while
all the while sucked inexorably into the fatal inertia of that black
hole we call techno-culture.

Baudrillard's Politics

Finally, for a theorist who has so violently rejected the space of
the political, Baudrillard remains one of the leading political
theorists of the late twentieth-century.

Not because he has finally made his peace with the necessity
of the political referent, but precisely the opposite. Baudrillard
can have so much to say about power in the postmodern
condition because his refusal of the modernist understanding of
politics, whether in its reduction of power to a theory of sover-
eignty, to juridical right, to a micro-physics of power without
roots, has opened his theoretical optic to the possibility of a
radically new analysis of power in the age of electronic politics.

Ironically, Baudrillard, the thinker who refused the political
theorems of Marxist orthodoxy, has provided in his writings a
comprehensive and critical account of the operational logic of
postmodern imperialism. In Baudrillard's political theory, power
now functions in the language of simulation, electronic politics
enchants the dark and missing matter of the society of "silent
majorities" by resignifying the specular domain of mass-medi-
ated images, and the irreality of control rests with those who
finally understand that we have irrevocably passed into the
next world of cynical culture, cynical commodities, and cynical
power.

Baudrillard's epic political vision is that of a relentlessly expanding imperialism of the cynical sign. Here, our age is that of seduction, not ideology; a time that will be marked by the strange, but compelling, logic of "imminent reversibility;" an era of a "machinery of solicitation," not manipulation where the only things that continue to fascinate are those containing the fatal promise of their own disappearance. A crash political theory, therefore, for a fin-de-millennium where all the traditional sign-referents deperately reverse themselves into their opposites. A crash culture where crushed subjectivity and political exhaustion are certain indicators of the triumphal ascendancy of a power that speaks in the langue of technology as art: a virtual power for virtual reality.

Baudrillard is one of very few twentieth-century theorists who have peered into the dark and cold galaxy of electronic politics, that floating world of political imagery as "hyper-objects," processed subjectivity, and TV as a digitally encoded ideogram. Not to theorize the crushing of human subjectivity by the universalization of cynical power, but for the practical purpose of providing a political vocabularly for thinking anew what has happened to us as we are fast-processed by the machinery of simulation. Consequently, the irony: Baudrillard the postmodern theorist who would refuse the honor of the name of ideology and who would seek to undermine the legitimacy of the political referent, provides us with one of the best existent methods for understanding the radical changes implied by the disappearance of politics into a global aesthetic of solicitation.

Consider, for example, Baudrillard's classic political text, *La Gauche divine*. While this book may have been written as a critique of the disappearance of (state) communism into power and of (French) socialism into cynicism, it represents a brilliant diagnosis of the transformation of contemporary politics into a

165

vast, labyrinthian machinery of solicitation.

> There is no longer a machinery of representation, only a machinery of simulation. No longer manipulation: it is not necessary to believe that citizens have been disarmed by power, dispossessed of their will-power. That is the old analysis cultivated by power itself in order to uphold the fiction of political alienation (it would like us to believe in its monopoly over the media, information and thought). Simply put, people live now in a simulation of citizenship; and power exists as a simulation of power. [4]

Not politics so much any longer, but the disappearance of politics into a simulacra of cynical signs. And emphatically not the disappearance of politics in general, but the vanishing of the political class (into ceaseless circulation along the model of the video game) and of political leadership (into the spectacle of publicity).

> The political class has virtually no specificity. Its element is no longer that of decision and action, but that of the videogame. The essential is no longer to represent, but to circulate.

> Politicians try desperately to do this: their interaction more and more assumes the form of special effects, of mood and performance. Even their ideology does not appeal to our profound convictions; it either circulates among us or it fails to circulate. [5]

> To the indifference of the political leader corresponds the smile of the leader. If our society is one of simulation, is it not appropriate that our leaders be great simulators, professionals of simulation? Reagan is the perfect representative of America. He represents the definite promotion of promotional culture at the level of politics, the revenge of the spectacle of publicity over politics and thereupon the revenge of the people over the political class. The age belongs to the smile of political mutants and their automatic optimism. [6]

166

But then, Baudrillard can understand so well the disappearance of politics into a machinery of solicitation because he has no politics at all. He is finally at liberty to mock the "automatic optimism" of the political mutants of the right as well as to satirize the nostalgia for the "referent" of the political left because his thought has long departed social theory, becoming a social myth. In a replaying of the more ancient language of mythology, Baudrillard's mind is that of a minotaur, a degree-zero point where all the signs go to be cancelled out, and perhaps to die. He is the first political theorist to be resolutely post-political.

Just as Baudrillard intimated in *Oublier Foucault,* power can only exist now in the presence of minotaur-like figures, often politicians but sometimes intellectuals, whose very presence in the world is a scene of sacrificial violence. Kings who work the game of a double seduction on power because they know power is dead; priests who dispense salvation because they recognize the death of God; and political theorists (like Baudrillard) who can write so compellingly about politics as simulation because they are already post-political. And just like all the kings and priests and politicians before him, Baudrillard knows that the penalty is a heavy one for exposing the purely cynical nature of power. That is why all of his books are terminal-events: violent scenes where opposite signs finally meet, only to burst apart in brilliant galactic starbursts. And this also explains the incredible global influence that Baudrillard's post-political political theory has had, not only over those interested in understanding the electronic world of politics, but for artists (the death of aesthetics), for sociologists (the death of the social), for cyberpunks (the death of technology).

Why the seduction of Baudrillard? It's just this. He is Bataille's *"part maudite."* That necessary part of every society that cannot be utilised and consumed, memorized or rationalised, but

167

always remains on the social horizon as a point of fantastic excess, all the more compelling for its resistance to assimilation. And just like Bataille's *part maudite,* Baudrillard's thought only exists to burn through the (seamless) social fabric with the white-heat of theory as sacrificial violence. But then, Baudrillard has already written out in *La Gauche divine* his own legacy:

> Our *part maudite* is indifference, this refusal of politics, this pact sealed in the silence of the majority, in a resistance mute and irrational where everyone is silently complicit, and where no social contract, no political solicitation is able to gain entry. [7]

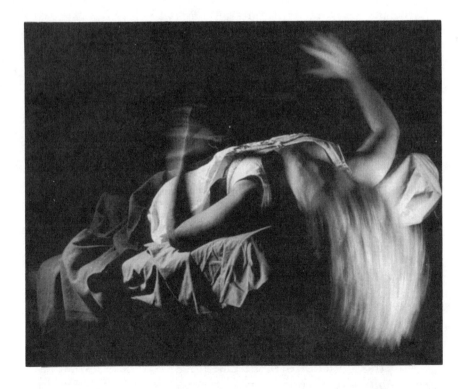

Photo: Warren Padula

11

Spasm: The Empire
Virtual America:
Let the Dead Bury the Living

"Like body surfers in amusement park machines, members of the submass are carried along by artificial forces that at once support them and provide sensory satisfaction. As the wave pool cancels physical effort by overriding any attempt to counteract it by force, fabricated culture molds undifferentiated want by the use of technological enticements and advertising...The submass reveals only a dissolved egoism."

James Cadello, "The Coming of the Submass"

Let the Dead Bury the Living

Virtual America? That is, the twin stars of America: cyber-America and sacrificial USA. Not opposite poles in the American mind, but mutating and instantly reversible signs in the uncertainty field that is the USA today. Here, the chief contribution of the United States to the history of the New World has been the development of a new theory and practice of political

regeneration, a process of violent renewal based on the continual transgression of the logic of the sign in the American mind. What Heisenberg first identified in high energy physics as the "uncertainty principle"—the triumph of probability theory and experience as a quantum fluctuation—was first developed in actual history in the *political* form of the United States. This is one society whose dominant historical experiences could so closely approximate post-classical science because the USA has always been a warring field between primitivism and technology. Virtual America *is* the uncertainty principle par excellence.

Anyway, what if Virtual America had already disappeared into its own hologram, actually vanished, and what we are left with is a photographic negative of its history. An irreal America passes for its concrete factual manifestations, while a real America becomes the cybernetic order of the mediascape. A transistorized, then digitalized, world of flashing memory impulses which take up no space because they are only empty quanta of memory elements. The cold chill of the screen with back-lit personalities. Here there are no politics and no society either, but only the suddenly concentrated and then dispersed flow of cybernetic pulses. A strange electronic world populated by chip personalities, where power mutates into information, information seeks only its own moment of cancellation, and where the body itself is seduced by its own metamorphosis into a servomechanism of digital reality. Not a violent world but cold and gleaming with metallic precision, and not a speeded-up world, but deeply inertial as everything moves past the speed of light to the ecstatic acceleration of the exterminism of information.

Virtual America is the USA as an empire of technology, where the will to technique has been so deeply interiorized as the essence of American being that technology is no longer an object which we can hold outside ourselves, but has become the dominant sign of American identity. Or, as Nietzsche has said:

170

"Let the dead bury the living."

Cyborg Puritans

What is so seductive about Virtual America is its political existence as the world's first digital culture. Having no history before the age of progress, Virtual America could also never be fully modernist: a society fated to oscillate in its deepest historical currents and enucleating political passions between medievalism in its ruling political mythology and quantum science. Thus, unlike Canada which is constitutively modernist and whose intellectual tendencies veer between a deep remembrance of its European origins and a critical reflection upon its present political predicament as a culture imprinted by the American hologram, Virtual America is that more fateful of political destinies. A society which, forming as it did at the very threshold of the technological dynamo in the European experience, worked out the fateful consequences of the dialectic of enlightenment in the colonization of the New World. While Hume could only hint at the interiorization of science into the flesh of technological society, American identity could be formed on the basis of a deep and abiding faith in the vision of technological willing as the essence of human freedom. While Marx in *Capital* could only write about the universalization of the commodity-form, the dynamic expansion of the American states across the North American landscape has grafted the theory of the commodity-form onto the politics (market democracy), the method of consciousness (pragmatic experimentalism), the life outlook (instrumental), the prevailing habit of mind (the war spirit leavened by spells of anxious melancholy), and the dominant occupation (merchant capitalism) of the American mind. While Locke could only theorize the triumph of contractualism as the essence of propertied human relations in liberal society, Virtual

America has blown the jurisprudential theory and practice of contractual liberalism across the social field. Indeed, Virtual America can be so seductive because it has made the technological dynamo its own, insisting that America is a unique historical creation that triumphs or perishes on the fate of technology. Here, the pioneering spirit could be explosively released in the dynamic mastery of social and non-social nature because in Virtual America the very meaning of the *frontier* is always a metaphor for the radical conquest of the future: the terrestial future of the American frontier and, now, the extra-terrestrial future of the electronic frontier. *Mondo America*, then, as the animating spirit of a fully technological society that has become *the* global aesthetic of all exit cultures.

Since the real religion of America is America, the United States can be doubly seductive because it fuses the question of technology with a missionary sense of liberation. While other societies have been reluctant to link their fate with the technological dynamo, Virtual America could become the technological society par excellence. Here, no false sense of cultural reserve holds back its citizenry from entwining their worldly fortune with the free play of technique.

And why should it? As a covenant with technology, America has always been a virtual society: the coming together of technologies of production, consumption, communication and, most of all, a technology of the (virtual) self. It is the religion of technology writ flesh: an unfaltering and unbridled faith in the possibility of radically making and remaking social and non-social nature into a means for the unfolding of dynamic freedom. Here, finally, was a *virtual population* with a triumphant battle cry (commercial freedom), with a unique sense of self (pragmatic individualism), with a collective political psyche steeled in the sacrificial blood rites of the Civil War, and with an unswerving sense of private property as a fundamental human right—who

172

could explode onto the scene of human history as the unfolding of the will to technological mastery of social and non-social nature. What could only be promised in early industrial Europe, with the fateful linkage of contractual liberalism and technology, came to fruition in the religion of technology that came to be called the United States. This is why Virtual America is the real Europe—the fulfillment in actual history of what could only be thought speculatively by the primal theoreticians of the European mind: Hume's prophetic insights into the inscription of science into the body; Bacon's paean to the experimental method of science; Locke's contractual theory of property rights. Virtual America is the European political metaphysics of the seventeenth- and eighteenth centuries inscribed in the historical materiality of the New World. What Europeans could only understand proximately—the dynamic unfolding of the technological dynamo in the name of commercial freedom—has always been the deepest animating spirit of the American mind.

With this difference. While Europeans could not see beyond the early industrial horizon of linking the commercial freedom of the marketplace with the systematization of technique, America came into existence on the basis of a deeper biblical covenant, *pentecostal capitalism*. In a way this is only suggested by the religious compacts of the early pioneering settlements of the Puritans. America was born a society of the Old Testament, the first of the genuinely biblical societies. Not biblical in the narrowly denominational sense—the USA has always been pluralistic in its choice of paths to the American God for this the society of freedom of consumer choice—but biblical in a deeper and more incalculable sense. It's as if the patron prophet of the American pioneering spirit was not Isaiah but Job, a prophet whose body could be covered with sores, besetted by maggots, betrayed at every hand, and yet who had an unflinching and undeviating faith in the rightness of his way. It's as if in America the two deepest informing impulses of the European spirit,

missionary consciousness and the will to commerical (techno-logical) freedom, which always remained in isolation midst the stagnant structures of the post-feudal European scene, could finally be fused into a new national combinatorial. Not as Weber's *The Protestant Ethic and the Spirit of Capitalism*, but as the infusion of the more ancient spirit of biblical consciousness with the will to commercial freedom as the American way.

America is a true psychological archetype, almost a random quantum fluctuation combining in a strange historical twist the ancient breath of biblical religion with a form of capitalism which was always *virtual* in its genealogy. Biblical capitalism. That's America today. Accordingly, while citizens of other (clonal) countries may make light of America's television evan-gelists and while they may scorn the choice of Hollywood actors for President, they miss entirely the primal beat of the American mind. Here finally was a political society where the greatest rewards go to those who sum up in the grain of their radio voices or the pixel images of their TV faces, a reenactment of the American Covenant: sacrificial heroes or villains who repro-duce in the autobiography of their political destinies the more ancient rites of sacrifice and redemption which are at the base of the American creed. If political success in the USA is always limited pragmatically by the practical necessity of protecting private property rights for the middle class, this is not to diminish the real political truth of the American way. Here, even in the midst of cynical power, political honors go to those who speak in tongues, who make of their bodies and destinies a vehicle for the articulation of more primal impulses: unswerv-ing missionary consciousness, lamentation over the sacrifices of those who have gone before, an undeviating faith in the possi-bility of practical redemption in the growing success of the American way, and a brilliant inability to think of the world in any other than the most sectarian technological terms. A *virtual people*, then, whose deepest subjectivity—with its celebration of

private property, its commitment to technological mastery, its vision of the freely acting self, its abiding faith in the American Covenant—is itself a brilliant expression of technological consciousness; whose emblematic (spatial) symbol is the soaring eagle transcending the material world of the snake; and who can drink so deeply of the simulacrum, with its ritualistic media images of the American pantheon—Elvis, Marilyn, James Dean, Madonna, Michael Jackson—because Americans have no need of external mythology. The American self is the world's first *virtual self*: always inventing and reinventing its identity, working by the doubled logic of (historical) exterminism of difference and the (cultural) appropriation of the sacred signs of the disappeared Other, and finding in the practical fact of citizenry in the empire of technology the fulfillment of human destiny.

Virtual Oedipus

Freudian psychoanalysis experienced such difficulty in being absorbed into the United States because the American self actually forgot to develop an ego. If it's true that the American individual is typified by a "strong sense of self, but a weak ego," that's because the American oedipal structure moves directly from libido to superego, with no mediation by the equilibrating ego. In fact, there is no American "I," only direct violent exchanges between a primal libido and virtual reality. Existing only virtually, the American self is a purely fictional site where the libido and the electronic vortex meet: a frenzied site where action happens, but when the energy switches are turned off, falls instantly into deep inertia. Like a wave pattern oscillating between manic buoyancy and anxious melancholy, the psychology of the virtual self is typified by the disappearance of the ego as a censoring mechanism. Here, impulses flash directly from the

primitive depths of libido to the electronic sky of the mediascape, and image viruses blast out of digital culture into the realm of liquid libidos.

There never has been a Freudian America with its modernist vision of the equivocating ego balancing between the id and the reality-principle, but there most certainly always has been a Kleinian America: an America where the self is mediated by object relations, with the virtual self as the most seductive object of them all. Consequently, Virtual America as the missing *third term* in world culture, that degree-zero point where things are fascinating only to the extent that they fall under the sign of exterminism and self-cancellation. In virtual reality, what is really interesting is only the hint of catastrophe contained in the system of objects, the suggestion of our own violent disappearance in the fatal speed of the electronic frontier.

Notes

8

1. George Bataille, "The Big Toe", *Visions of Excess: Selected Writings, 1927-1939,* edited by Allan Stoekl (Minneapolis: University of Minnesota Press, 1989), pp.20-21.

2. *Ibid.*, p.23.

10

1. Jean Baudrillard, *La Guerre du golfe n'a pas eu lieu,* (Paris: Galilee, 1991), pp. 57-58.

2. *Ibid.*

3. Bruce Sterling, *Islands In The Net* (New York: Ace Books, 1989).

4. Jean Baudrillard, *La Gauche divine: chronique des annees 1977-1984* (Paris: Bernard Grasset, 1985), p. 112.

5. *Ibid.*

6. *Ibid.*, pp. 114-115.

7. *Ibid.*, p. 136.

imprimerie gagné ltée

PRINTED IN CANADA